GW00359495

OUR SONGBIRDS

A SONGBIRD FOR EVERY WEEK OF THE YEAR

MATT SEWELL

EBURY
PRESS

3 5 7 9 10 8 6 4

Published in 2013 by Ebury Press, an imprint of Ebury Publishing

A Random House Group Company

Text and illustrations © Matt Sewell 2013

Matt Sewell has asserted his right to be identified as the author of this
Work in accordance with the Copyright, Designs and Patents Act 1988

The Random House Group Limited Reg. No. 954009

Addresses for companies within the Random House Group can be
found at www.randomhouse.co.uk

A CIP catalogue record for this book is available from the British Library

The Random House Group Limited supports the Forest Stewardship
Council® (FSC®), the leading international forest-certification
organisation. Our books carrying the FSC label are printed on
FSC®-certified paper. FSC is the only forest-certification scheme
supported by the leading environmental organisations, including
Greenpeace. Our paper procurement policy can be found at
www.randomhouse.co.uk/environment

To buy books by your favourite authors and register for offers visit
www.randomhouse.co.uk

Printed and bound in Italy by Printer Trento S.r.l.

ISBN 9780091951603

CONTENTS

Dedicated to the memory of Bill, Bob,
Kath & Jenny

FOREWORD

If there's one type of bird I have a strong
affinity with, it's definitely the singy songy
fellas. They kind of wake up the world with
their vocals. It's a little known fact, but that's
not them getting up, you know; it's them
having not been to bed yet. Often they've had
a drink, too. They're feathery show offs. Who
cares that an albatross has got the biggest set
of wings – those dudes are bad luck. Nope,
believe me, it's the songbirds that are the
open-beaked frontmen of the feathered world.
Long may they rock . . .

Tim Burgess, The Charlatans
October 2012

INTRODUCTION

Birdsong is a part of the natural stereo
soundtrack to our everyday lives. Some songs
stop us in our tracks with their warmth and
dexterity, but mostly the quacks, clucks, trills,
tweets, kronks, peeps, zing pings, keee-orrs
and crowings go ignored or unnoticed. Sadly,
some of these songs aren't half as common as
they used to be, whilst some songs are growing
in popularity day by day. The sound of birds is
all around us; we just have to stop and listen.

DAWN CHORUS

Not a music television presenter, though I did
actually have a music teacher at school called
Mrs Melody. An hour before the sun rises over
the horizon in spring, the woodland choirs stir
and warm up their vocal cords and the misty
morning air with songs and sine waves of every
shape and colour. Throughout the season
each choir grows with newly arrived migrant
visitors, building dense layer upon layer and
eventually creating a cacophony of industrial
proportions. A heady brew that we mainly just
sleep through.

Scientists can't explain the Dawn Chorus
as it doesn't seem to serve much purpose or
practicality; I doubt they ever will either,
as they can't logically explain that the birds are
full of the joys of spring and so glad to be alive
that they sing their songs to the rising sun
with gusto.

Lapwing
Vanellus vanellus

Once a common voice within our aural
landscape, the call of the Lapwing was heard
loud and clear throughout British arable lands,
meadows and marshes. So common a sound,
in fact, that many people know this handsome
plover, resplendent in a green and black
iridescent smoking jacket, by his call alone:
the 'peewit'.

It's an instantly recognisable call that matches
his distinguished look and territorial acrobatic
aerial displays. Due to changes in farming
techniques and increased use of pesticides,
Lapwing numbers have hit crisis level,
dropping disastrously in the last thirty years.
That is why the peewit sings the blues.

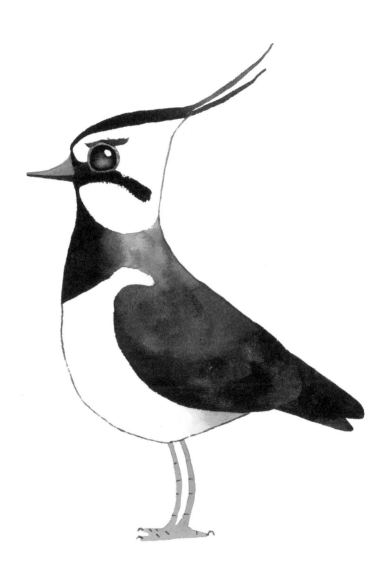

Bittern
Botaurus stellaris

Deep in the marshlands, far beyond where
any Coot or Moorhen dares to tread, dwells
a creature part myth and part Heron; a bird
rarely seen but widely talked of in hushed
tones, as if the slightest movement ten miles
away will push him deeper into the fen. Every
spring the male stealthily makes his way
through the reeds to a clearing at the water's
edge and releases his guttural sonic 'boom'.
Like the sub-bass of an illegal rave, the boom
can be heard through the countryside for up
to a mile. The Bittern huffs in air, filling his
neck like a pair of tweed bellows, and in a
controlled bark gently releases the sound in the
hope of arousing a lady Bittern, who is just as
clandestine and shy as her beau with the boom.

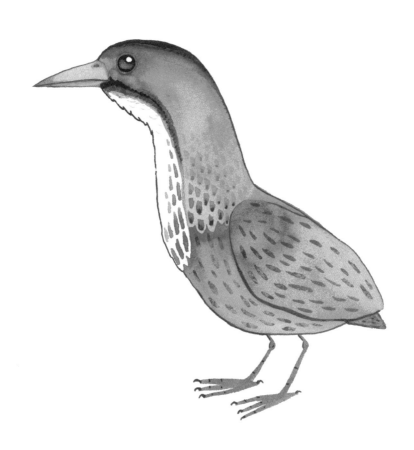

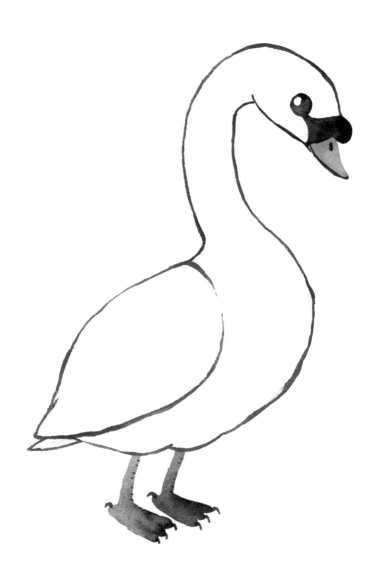

Mute Swan
Cygnus olor

For a bird that is supposedly mute, this
graceful and iconic river dweller isn't half
a parrot. With grumbles, groans and a
pantomime villain's hiss, the Mute Swan is
very much an audible presence within the
world of birdsong. My most treasured swan
song is heard when the cygnets are looking
big, confident and fluffy as they follow their
proud parents upstream, yet they still have the
squeaky voices of week-old puppies.

Canada Goose
Branta canadensis

We all know this Canadian mob from parks and the riverside, familiar with them putting on a hustle for bread crusts or just generally hanging about as if they were people too. They're not aggressive, they're just trying to fit in. That's what is immediately striking about these introduced waterfowl: their friendliness. You would never catch any other geese being quite as polite as they arrive at their second home for the winter months.

As admirable and affable in company as the Canada Goose is, you can't beat the sight of a great wedge of them, spread in a V formation against the autumn sky, 'honking' their heads off. Like a group of lads between pubs, the configuration just about holds together, powered by sheer determination.

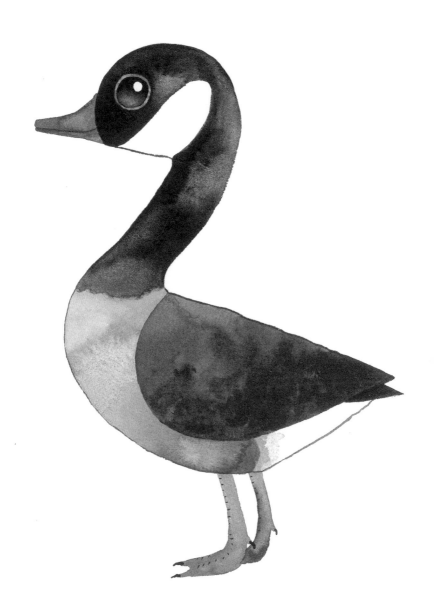

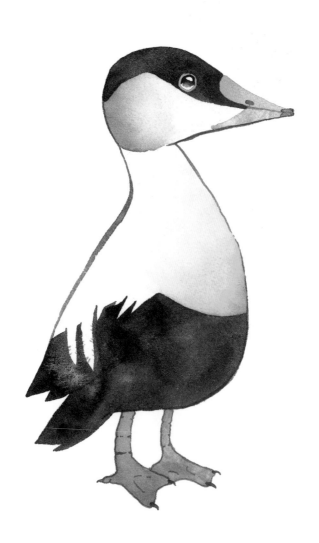

Eider
Somateria mollissima

Found way, way up north, these salt-water ducks are big old boys with lovely soft feathers. Their prattle sounds like gossipy conversation behind another duck's back: 'oohs' and 'aahs' rather than the 'quack quack quack' we're used to from the irrepressible Mallards that frequent every neighbourhood in the UK.

Coot
Fulica atra

Why not a Moorhen? They're prettier, with
a red and yellow head shield, not bald as a
Coot . . . But have you ever seen a Coot's feet?
Exactly! Like weird, scaly, deflated washing-
up gloves, which handily help them to walk on
water (if the water is full of weeds, that is).
The size of a Moorhen wearing a swimming
cap, the Coot is not really known for his call,
but you will recognise it as a loud honk.

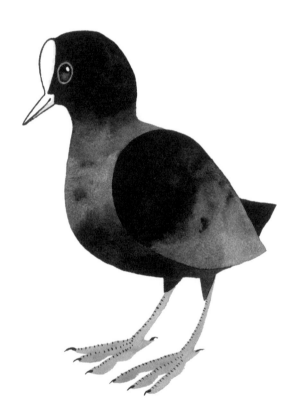

Oystercatcher
Haematopus ostralegus

A sturdy, handsome pied coastal bird with a
taste for all manner of cockles, limpets and
other molluscs. A born romantic who doesn't
rely on his scintillating orange beak, fancy
dancing and aphrodisiacs to lure the ladies;
the Oystercatcher just sings (or shouts, to be
honest) his heart out. It's not the prettiest
of songs by any stretch of the imagination,
but it certainly works.

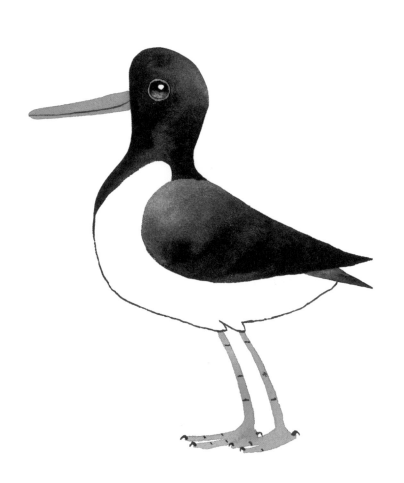

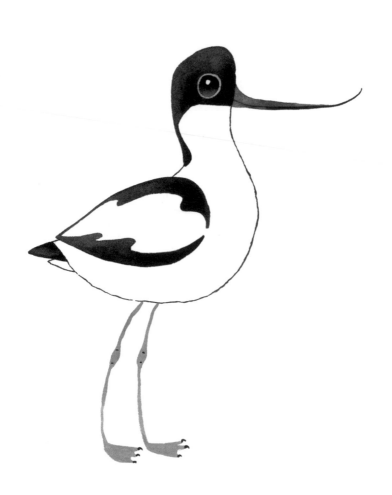

Avocet
Recurvirostra avosetta

Striking, elegant and graceful, the Avocet
belongs on the catwalks of Paris rather than in
the boggy coastal sanctuaries of Suffolk. Alas,
for such a stunner, the call is a croaker, but
then again I bet *you* would sound a bit weird
with your nose pointing upside down.

Snipe
Gallinago gallinago

With a beak like a broom handle, it's not hard to see why a song isn't always on the lips of a Snipe. A mottled coat for camouflage rather than flirting, and a song for conversing rather than courting, it's the Snipe's aerial flare that is a hit with the ladies. That 'peep peep peep' doesn't sound too bad now, does it?

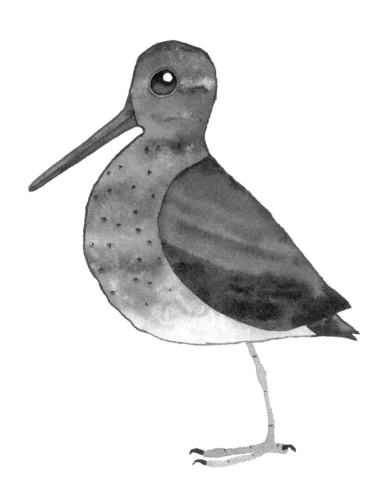

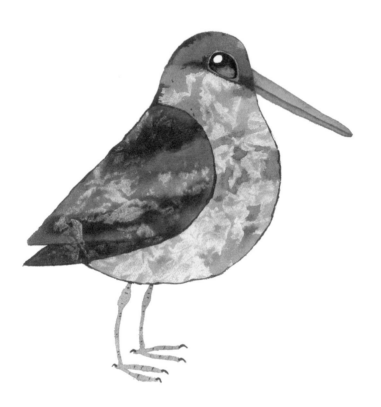

Woodcock
Scolopax rusticola

Something he's eaten doesn't agree with the Woodcock – you can hear him coming a mile off: 'Fart fart fart Peep! Fart fart fart Peep! Fart fart fart Peep!', or a couple of shuffle pumps and a tommy squeaker, to give the 'song' its scientific name. It's hard to imagine that this little set of bagpipes is considered a delicacy and hunted in many parts of Europe. Best advice I can give the poor chap is to keep upwind of the idiots with the shotguns.

Curlew
Numenius arquata

You're lost in the foggy marshes, you hear
a ghostly wail . . . is it the Hound of the
Baskervilles? Cathy searching for Heathcliff?
An American Werewolf in Yorkshire? Nope,
you're probably hearing the melancholy sonnet
of the Curlew. Taking into consideration his
largish size and amazingly long beak, this
estuary bird is quite adept with sound, and
his sad lament has become a favourite with
fishermen and riverside ramblers.

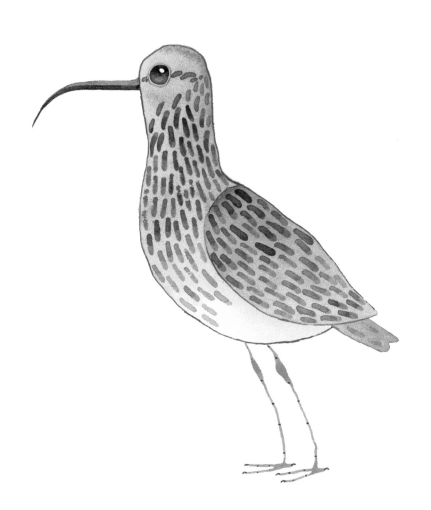

Great Black-backed Gull
Larus marinus

Nature's cruel messenger. Big as an Alsatian – and keeps growing to the ripe old age of thirty – with a menacing glare and a fearsome, permanently blood-stained beak that could have come from any poor animal, bird or person. Top of the food chain, nothing is off the menu for the Great Black-backed Gull. An ear-splitting 'kee-orr' shriek announces his arrival, a squall that must have felt like the most welcoming of serenades to the ears of sailors returning to dry land after years away on the high seas.

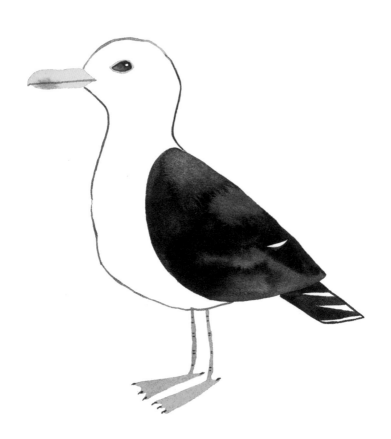

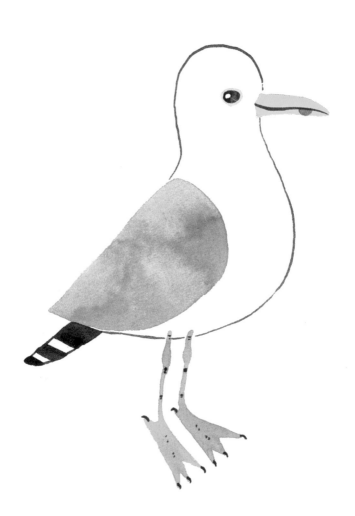

Herring Gull
Larus argentatus

The disturber of peace, the raider of bins,
the mugger of vinegary chips and ice creams,
the wheeling circler of rubbish dumps, and the
sound of a thousand sunny seaside memories.

Kittiwake
Rissa tridactyla

This sweet, inky-fingered seabird, like the Cuckoo and Chiffchaff, can quite happily talk about himself all day long. Usually found far out at sea or in the centre of Newcastle upon Tyne – a strange home for such a beautiful bird with a beautiful name.

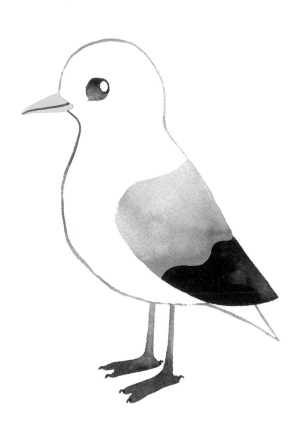

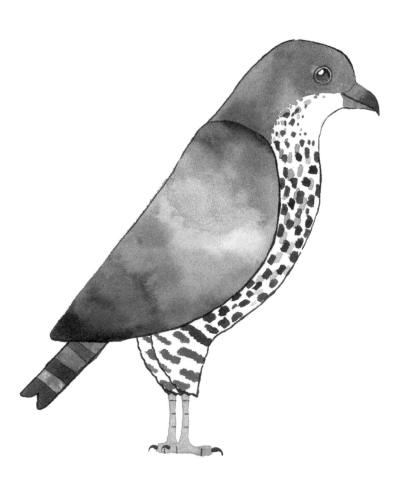

Honey Buzzard
Pernis apivorus

Slimmer in shape and lighter in colour
and tone than the very common Common
Buzzard, whose 'kiiiaaaw'-ing can be heard the
length and breadth of our isles. With honeyed
tones, this buzzard sounds sweeter, like a cat:
'peeeow'. A much rarer and delectable spot for
the trained eye . . . here kitty, kitty.

Golden Eagle
Aquila chrysaetos

Like most big dudes, the Golden Eagle is a man of few words, keeping it for the eyrie only. His wheezy, whistley snore or high-flying yelps during cartwheeling courtship displays aren't really that necessary to identify this magnificent bird of prey. Such an awesome and devastatingly handsome fellow needs no introduction. Rugged, heroic and staunch, spiralling over the Highlands with a wingspan of over two metres, whose contours cut a totem against the sky, the Golden Eagle is such a treasure that even the mountains of Scotland are proud to have him call them home.

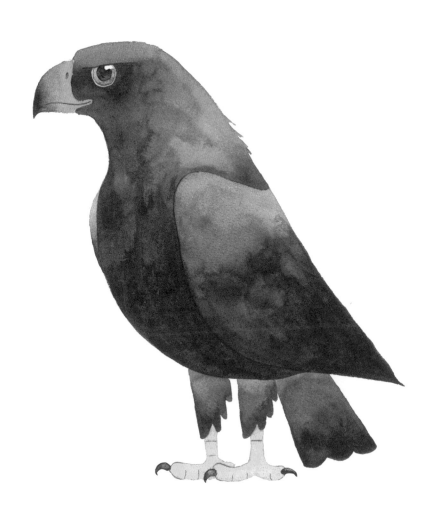

Peregrine Falcon
Falco peregrinus

That descending screech is a bell tolling for
some poor pigeon about to be struck by the
lightning bolt that is the Peregrine Falcon.
Not only is it the fastest bird in Britain, it's
the fastest animal on the planet and the only
sentient being that can break the sound barrier.
Originally a cliff dweller and the prized bird in
falconry, selected only for kings and noblemen,
this majestic blue-grey falcon fell out of favour
after the Middle Ages and was persecuted and
poisoned to near extinction. Tragedy closely
averted, numbers have been on the rise and
their distinctive cry can be heard in many
cities, taking up roosts in high-rise blocks,
cathedrals and water towers.

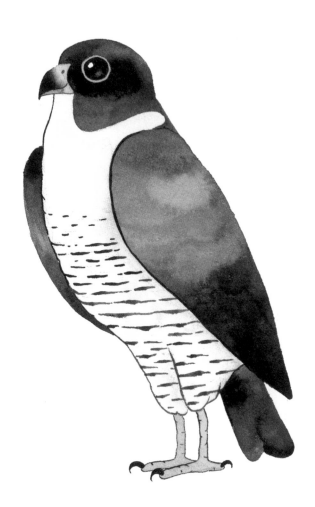

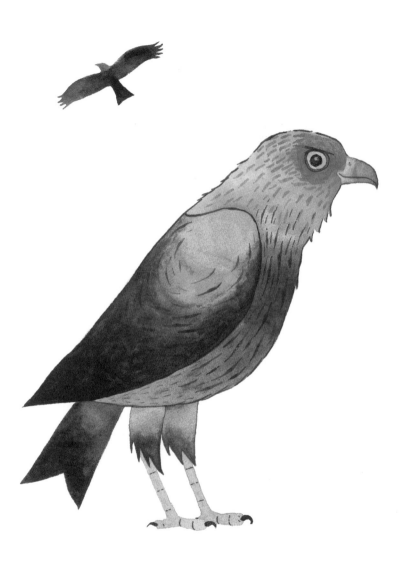

Red Kite
Milvus milvus

It's hard to hear a Red Kite, as it will probably be drowned out by the deafening din of the motorway. Once one of the most common birds of prey in Britain and a symbolic silhouette in medieval skies, the Red Kite was a city scavenger. Imagine what it would have been like if these massive raptors had replaced pigeons – terrifying but awesomely amazing! They were such a common sight that the name for a toy kite actually comes from the bird.

The kites were eventually hunted, poisoned and persecuted until there was nothing left but a Welsh stronghold of a few pairs, secreted away in the lush green valleys. Now, through the reintroduction work of ornithological philanthropists, they are a common sight in some places and block out the sun in others, cheering up many a journey along certain motorways and bus routes of the British Isles.

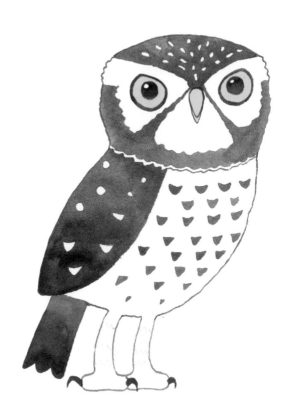

Little Owl
Athene noctua

This tranquil little fellow can often be found
in daylight, meditating on a fencepost or just
absent-mindedly watching traffic. Bid him
'Good day' and he will nod his head in respect
and reply, 'HullOOO!', before bobbing off
and flying low to a quieter spot where he won't
be bothered by nosey well-wishers.

He doesn't possess the most famous of
nocturnal calls, but he is easily the most
polite of all our owls.

Long-eared Owl
Asio otus

With the dirtiest of looks, it's easy to feel as though you're being coldly judged by this debonair, horned owl, brimming with menace – especially as he is looking you up and down, chastising you with an 'oooh' and 'euurrgh'. The Long-eared Owl, arrogant and vain, with every right to be. What a dish!

Owls are deeply engrained in our consciousness. The Tawny Owl's 'too-wit too-woo' is a phrase we learn in childhood and never forget. In bygone times the Barn Owl's chilling shrieks have caused these cute creatures to be perceived as symbolic omens of death.

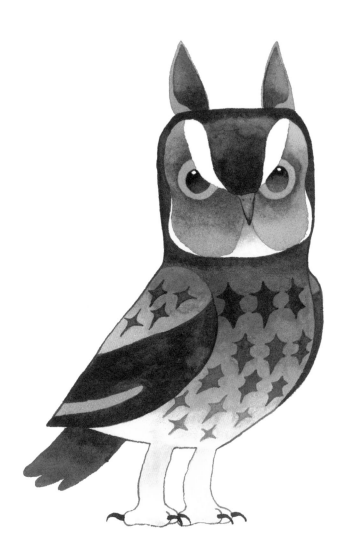

Raven
Corvus corax

Magpies have a death rattle for a song, the Jay
shrieks like a startled widow, Jackdaws yack,
Rooks cluck and Crows crow. But only the
Raven has a 'kronk'. Rolling his 'r's like a local
yokel, the Raven loves to mouth off high in the
sky above mountains and rocky outcrops,
the guttural command uneasily appreciated by
fell walkers, farmhands and anybody else
in its range.

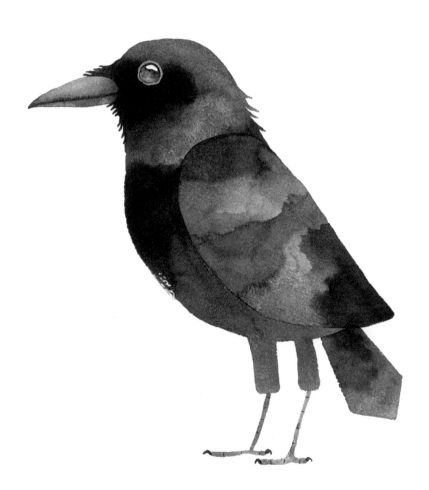

Capercaillie
Tetrao urogallus

Amongst the pine trees, the blues of the Scottish Peacock are only witnessed by a lucky few in arboreal Scotland. Pheasants croak, Red Grouse bark and Partridges burst out of the undergrowth shouting 'quick! quick! quick!'. All game birds are known for their rustic, Arcadian coats of feathers and their blusterous outbursts, but none more so than the mighty Capercaillie, whose muscular courtship display is accompanied by the strangest of fanfares, like a ping-pong ball being rattled around an empty vessel. Honest!

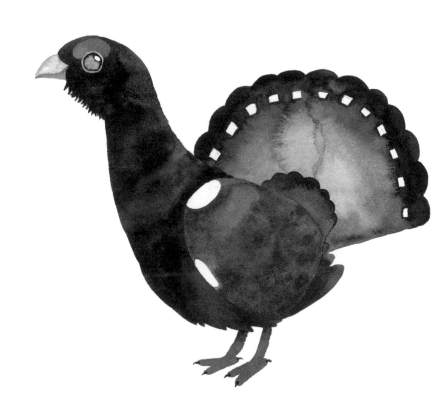

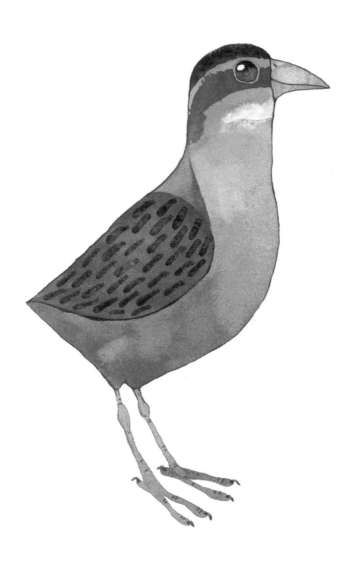

Corncrake
Crex crex

The Corncrake is a mysterious, antiquated water
bird that took a fancy to dry land and never
went back.

Favouring meadows and tall grass, the
clandestine Corncrake is as secretive and
cautious as an elusive Water Rail, imperceptible
amongst the bullrushes and reeds.

His call is just as enigmatic as his curious
nature, a cryptic, clicky oscillation in the fields,
like a mobile phone vibrating in the middle of
the night. But louder and weirder,
much weirder.

Turtle Dove
Streptopelia turtur

A glamorous granny resplendent in lace, doilies and pastel knickerbockers. The Dove's gentle purr could lull even the most active of minds to sleep whilst sitting in the shade of an oak tree. A rare sight that is becoming rarer every summer – they don't make them like that any more. And to think that in some areas of Europe it is actually considered sport to shoot these beautiful birds.

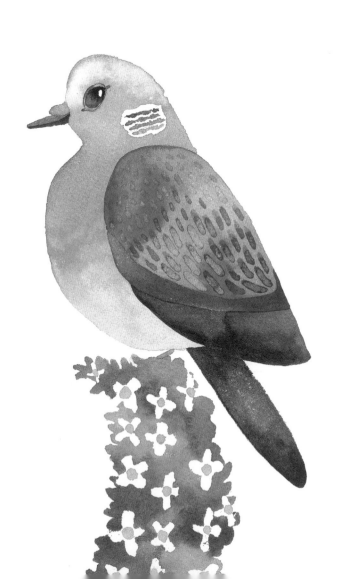

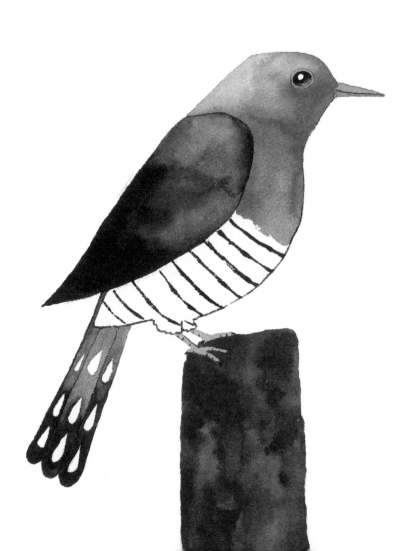

Cuckoo
Cuculus canorus

Kuckuck in German, *Coucou* in French,
Guguk in Turkish and *Côg* in Welsh, he
may have a different accent but he's always
saying the same old thing. Yet our Common
Cuckoo is just one nut in an extensive family
of fruitcakes, which takes in parasitic brooders,
dwarves, parental role swappers and long-
legged ground birds such as the Roadrunner in
America: 'meep-meep!'. No, excuse me Sir,
I think you'll find it's 'cuck-koo!'.

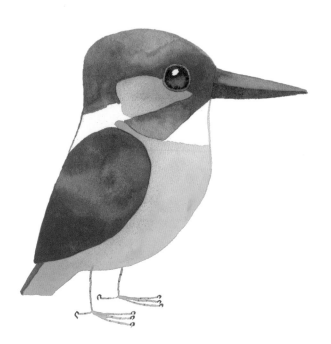

Kingfisher
Alcedo atthis

A bird from the absolute elsewhere, the
Kingfisher is a celestial work of art. So
otherworldly that even he's aware that looking
upon his tiny frame can make mankind ask the
biggest of questions and doubt all that he knows
and has ever been told. So, kindly, he offers us
just millisecond glances or fleeting dashes until
he's off to blow the next yawning mind.

With a miniature cloak of incandescent blue
and a chest orangier than a polished satsuma on
Christmas morning, one would expect a song of
sublime delicacies, an ethereal paean to herald a
gathering of monarchs and magi. Unfortunately,
to be the king of all fishermen requires you
to have a brutal dagger for a mouthpiece,
resulting in a taut, high-pitched whistle of a call.
Disappointing maybe, but study this whine and
you will stand a much better chance of spending
time with the most brilliant of all British birds.

Nightjar
Caprimulgus europaeus

Half Owl, half Swift, half Bat, the Nightjar
is a very strange bird indeed. With nocturnal
habits, big eyes and an even bigger mouth,
the Puck Bird has mystified the human race
for centuries. It was widely believed that the
dude's big mouth was used for stealing milk
from goats rather than catching big, dusty
moths, a suspicion so strong that his Latin
name actually means 'goat sucker'.

Such an otherworldly bird deserves an
altogether esoteric song. Which is a cryptic
drone, a wooden mechanical clockwork
on hyperdrive, like a ghost in a pre-steam
machine. Spooky.

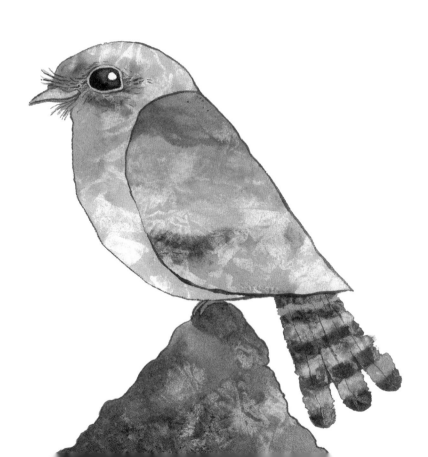

Swallow
Hirundo rustica

Of all the high-flying birds, the Swallow's song is the sweetest. After an epic journey following magnetic energy lines across Europe, the chitter-chatter of House Martins and the arcane screams of Swifts combine with the Swallow's chirrupy song, arriving just in time to create everybody's soundtrack to the summer.

The Swallow's social song is sung on many occasions – up in the blue, in the nest or on telephone wires – but my favourite is heard at the beginning of autumn when all the Swallows have congregated, packed their bags and are heading back on intercontinental airwaves to Africa. The last few young stragglers excitedly bound over the hills together, singing the same song, but this time with sheer joy at the first wingbeats of their first big adventure. Don't forget to send a postcard!

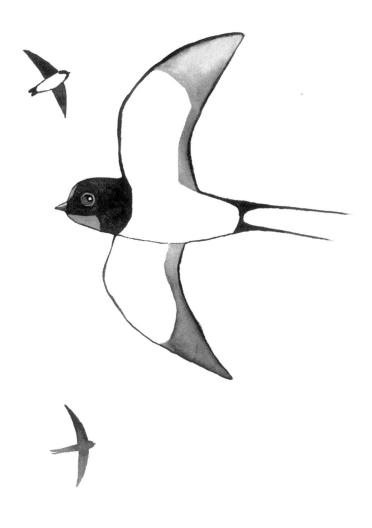

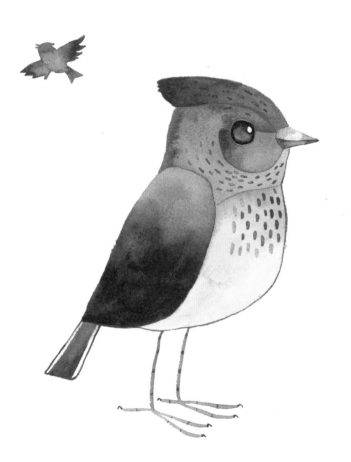

Skylark
Alauda arvensis

There are many sights, sounds and smells of British summertime, and the spotting of Skylarks is a heady, alchemical mix. They fly high and hover above meadows, singing crystalline enchantments before parachuting down into the undergrowth as if protected by the notes. The Lark rises and breaks hearts.

Shorelark
Eremophila alpestris

This foreign devil frequents our eastern shores
from time to time with other Scandinavian
visitors, the Waxwing and Fieldfare. Keeping it
strictly coastal, this fellow sings his song on the
wing like all larks, above the shingle and sea
spray. An amazing winter spot for anybody
to behold, with his sushi chef outfit and
striking tones.

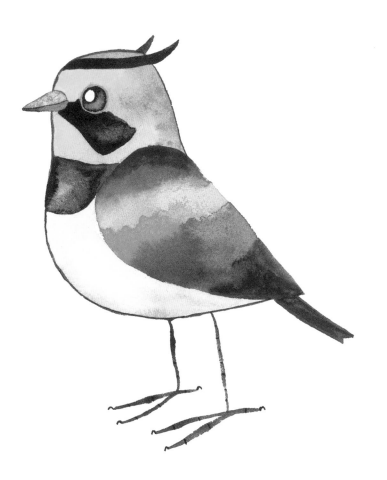

Wren
Troglodytes troglodytes

There are many wrens around the world –
Carolina Wrens, Riflemen, Rock and Bush
Wrens, Splendid Wrens and Blue Fairy Wrens
– but none maybe quite as loud as our
humble, tiny Common Wren. Roughly the
size of a thimble but with a scold that could
scorch earth.

Wood Warbler/Willow Warbler/Chiffchaff
Phylloscopus sibilatrix/ Phylloscopus trochilus/ Phylloscopus collybita

Now, being a man of the world, I don't want to come across as an abhorrent, bigoted warblist, but I have a terrible time telling the difference between a lot of the warblers – they all look the same. But the trick with many a warbler is just to sit and listen to what they are saying and you will immediately hear that each is an individual with rattles, long, looping languid songs, sweet peeps, wolf whistles and chiffchaffings.

Whitethroat
Sylvia communis

Another warbler that is not easy to spot but is so contrasting to our native warblers that he's not hard to identify or name; like the Blackcap, his name is on the tin. Much bigger and thick-set than the rest of his warbling brothers, with a gruffer voice and sturdy song to match. He's not here for long – summer only – travelling and seeking a temperate climate away from his home in Africa. Where I'm sure he fits in a treat.

Garden Warbler
Sylvia borin

A diamond in the rough in every sense,
a diminutive wheaten songbird whose hidden
talent of singing is a closely guarded secret.
Even her Latin name is 'borin', and in true
plain-Jane style she veils herself in the leafy
undergrowth and recites her lovely deep song
– like a shy teenager hidden in her bedroom
singing love songs into a hairbrush. Singing
for themselves.

Which is the very opposite of close family
member the Sedge Warbler, who stands tall and
proud and fires out his scattergun, avant-garde,
never-ending song of non-repetitive peeps into
the marsh. Letting everybody within firing
distance know that he's got a voicebox and
he's gonna use it!

Bearded Tit
Panurus biarmicus

Ping! Ping! Piercing Ping! Almost inaudible,
it must be a nightmare for any dogs that live
in marshes; poor wet dogs driven to madness
by a high-pitched cacophony. An absolute
beauty of a bird: striking eyewear, pastel tones
and long, luxurious tail feathers. Sartorial and
gorgeous. A treasured spot for even the most
dedicated and jaded of bird spotters, never
mind us mere nature aficionados.

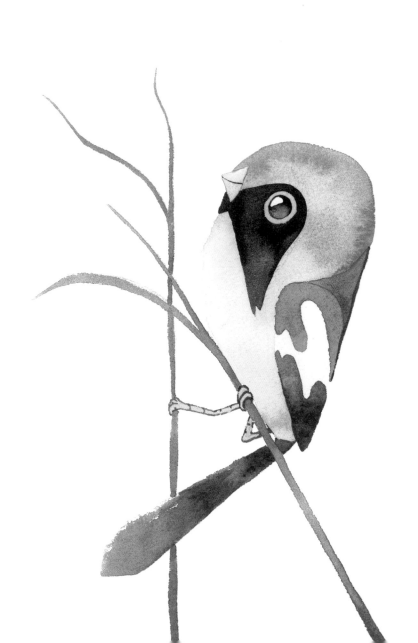

Pied Flycatcher
Ficedula hypoleuca

No, he hasn't just caught a fly, those are his bristly whiskers. An exceptional spot if you see one, as they are beautiful and infrequent summer visitors. Oodles of charm with a cheerful song, though not half as common as their duller cousin the Spotted Flycatcher, who sounds more like a squeaky wheelbarrow.

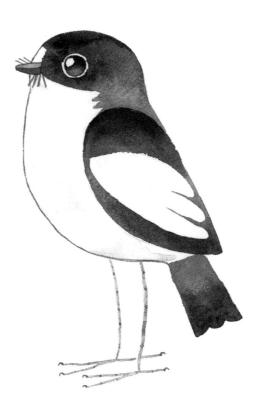

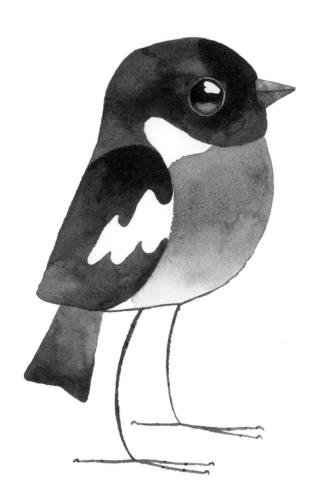

Stonechat
Saxicola torquata

Chat chat chat, indeed. Favouring moorland,
whin bushes and heather, this handsome,
thickly accented, coarse-singing uplander has
an alluring orange chest and an alarming song.
Ever vigilant and vocal, like an Inspector Gorse
advising all his flighty familiars that there is a
weird chap with a pair of binoculars coming
their way – it's probably time to dart further
out of view into the barbs and thistles . . .
Damn you Stonechat and your fastidious ways!

Wheatear
Oenanthe oenanthe

Keeping their distance on fellsides, Wheatears
are like the proverbial mountain peak that
keeps disappearing above and away into the
clouds. If you get close enough to gaze upon
his splendid blue gilet, you could also be
lucky enough to see him perched on a rock
whistling his perky, bright tune.

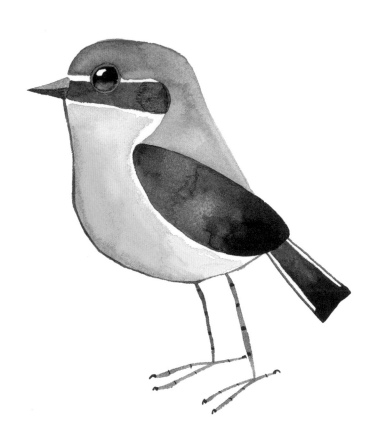

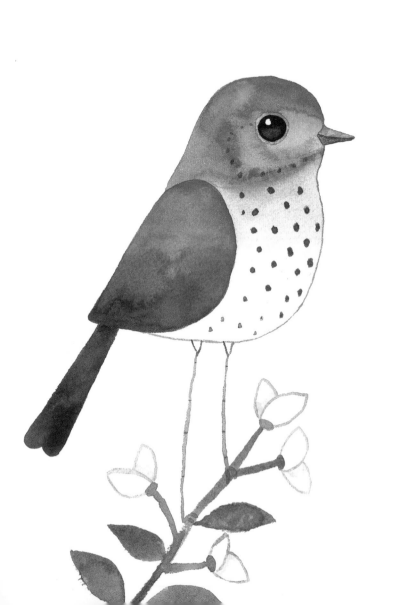

Meadow Pipit
Anthus pratensis

There are many pipits – Rook, Tawny and
Tree – but the Meadow is a mini Song Thrush
in the making in spirit and looks. Lively and
social with a complicated song that you could
never dream of learning the words to,
so don't even try.

Robin
Erithacus rubecula

Not just for Christmas, the Robin sings his
song all year round, and what a plethora of
numbers these gusty red-breasted folk know:
carols, aggressive fast numbers, golden oldies
and ballads as soft as snow. The Robin's
greatest hits are a treasured possession in many
a garden and park.

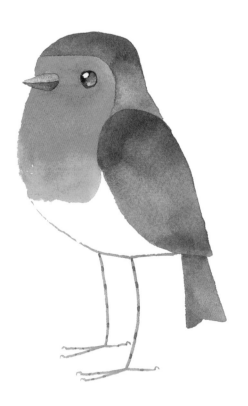

Nightingale
Luscinia megarhynchos

He may be a household name, but could
you recognise a Nightingale walking down
the street, or even name one of his tunes?
Didn't think so. The legendary status of the
Nightingale's song has all but eclipsed the
corporeal existence of this rather dull-looking
Robin. But being a shy and retiring individual
I'm sure he doesn't mind that his talents get
all of the limelight, and it doesn't matter how
far into the hedgerow he hides himself, his
luminous molten song will be greeted as a
blessing and glorified in folklore. If you are
lucky enough to hear a Nightingale's song,
treasure it with both ears, hold it in both hands
and tell the world.

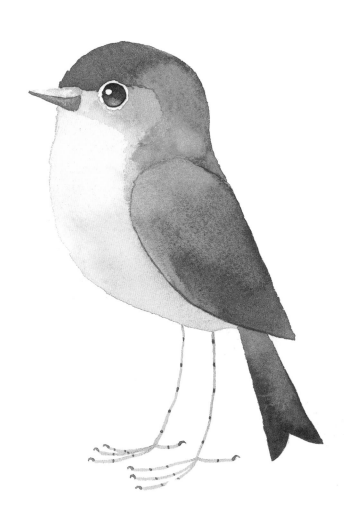

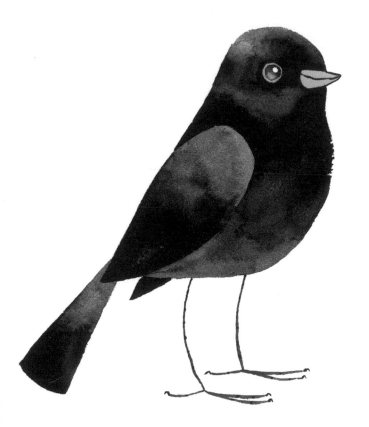

Blackbird
Turdus merula

The most common bird in Britain. Originally
a woodland bird who has taken to the urban
environment like a Kingfisher to water. With
reassuring 'clucks' and trumpeted melodies,
the Blackbird's songs are appreciated every day
and everywhere.

But heaven forbid you accidentally step within
ten metres of their nest. A brave Blackbird will
meet you eyeball to eyeball and blaze an alarm
with the same gusto as the captain of a burning
boat singing battle hymns into the face of
forty-foot waves. A fearsome siren that is a
vital early warning system for all birds in the
locality, especially when there's a troublesome
cat out stalking. Raise the alarm!

Song Thrush
Turdus philomelos

A true professional in the old-school sense,
a crooning garden favourite who belts out
every number like it's the finale to a grand
show. Poetry, sonnet and life story, his song is
perfected over years, added to and polished and
always delivered with such heartfelt zeal,
it doesn't matter whether he is headlining
at Wembley or singing in the shower.
A songbird in every sense.

Dartford Warbler
Sylvia undata

Like a singing thistle in a bobble hat.
A regular visitor from southern Europe who
only holidays in certain locations and would
never dream of going any further north than
the Dartford Tunnel. A rare groove of
Euro-flavoured melodies graces the gorse
bushes of these lucky boltholes. It's a real
shame for all of us that this warbler isn't
a little bit more adventurous.

Blue Tit
Cyanistes caeruleus

Like all tits, the dextrous Blue Tit is not
renowned for its songs, but its high-pitched
cheeps, peeps and squeedle-deeps.
A reverberation that people are so accustomed
to, it's generally ignored in everyday life as
we are so ensconced in it, like a feathery
comfort blanket.

Being surrounded by a family of Long-tailed
Tits and their sharp, pin-prick call is like
rolling in nettles if they sang rather than stung.
The family that sings together flocks together.

Willow Tit
Poecile montanus

Could also very easily be labelled as a Marsh
Tit as they are practically the same bird but
with the slightest difference in marking, but
I went for the Willow as I prefer the name. Plus
you don't actually find Marsh Tits in marshes.
You don't find Willow Tits exclusively in
willow trees either, but we'll let that one slip.
Both of these birds and their 'zee-zee'-ing
calls are regular spots on rainy walks up rocky,
woodland hills.

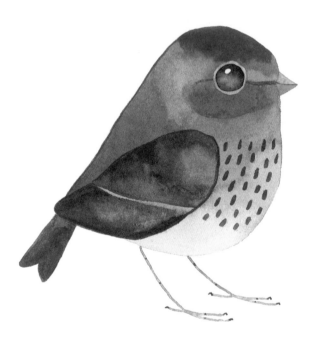

Twite
Carduelis flavirostris

Or Pennine Finch, a local bird for local people.
Nothing much to look at: a faded Linnet or
rejected Redpoll. A plain northern bird that is
definitely a finch in cuteness and stature, but
does her own thing and sings her own song,
a song so personal she is named after it. There
is more to the Twite than meets the eye.

Bullfinch
Pyrrhula pyrrhula

Eavesdrop on a Bullfinch and you will hear
a simple but melancholic song: two minor
chords plucked on a harp. We all know the sad
ones are the finest ones. Best appreciated on a
crisp, blue-sky winter's day.

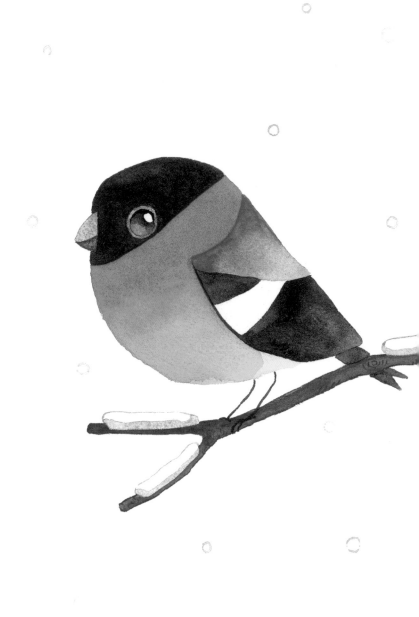

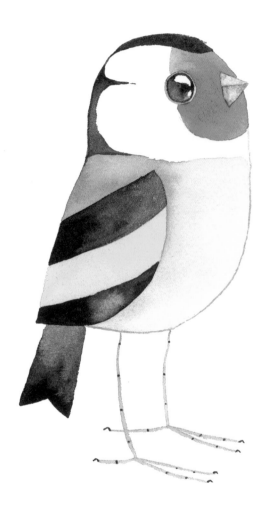

Goldfinch
Carduelis carduelis

Finches have many calls, alarms and greetings.
My favourite one of all is the squeaky chatter
of a charm of Goldfinches; family and friends
bond within an applause of bouncy squeaks,
as though it is their sheer pleasure to sing
and belong to a chorus. Unfortunately, the
Goldfinch is one of the only British birds that
sings whilst caged; listeners would revel in the
array of sounds and beauty when actually
the finch was pining for his charm.

Dipper
Cinclus cinclus

A fat Wren? A wrong Robin? A suicidal
Sparrow? A mixture of all? It's easy to get
confused by a Dipper as he is an anomaly
amongst our songbirds, preferring to spend
most of his time running around feeding
underwater. He bobs about from stone to
boulder, quick as a ball stolen by the current,
all the time reciting his immaculate,
crystal-clear song that he learnt note by note
from the river.

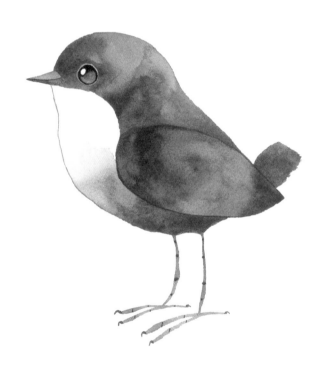

Yellowhammer
Emberiza citrinella

All buntings are jittery jibber-jabbers, keeping the meadows, hedgerows and hillside updated about the slightest detail with nervy, high-pitched chatter and signals. The Yellowhammer is no different, a keen prattler and doom-monger who also loves to sing his lunch order of a flustered 'a little bit of bread and no cheese!' It ain't all bad news then . . .

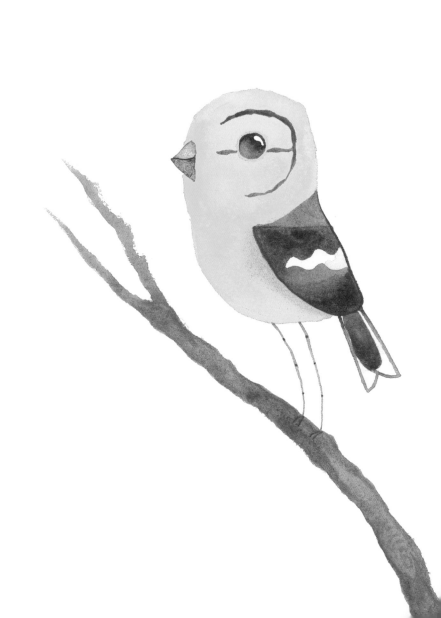

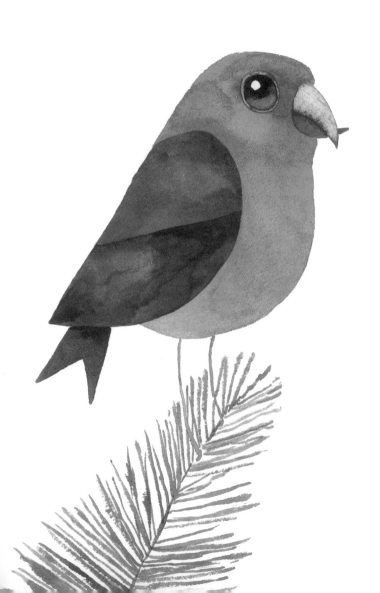

Crossbill
Loxia curvirostra

My maths teacher used to ask me how I would tell jokes with no teeth. Likewise with this chap, how's he going to sing with crossed chops? Not very well, is the answer on both occasions.

The Crossbill is a Scandinavian Alpine Finch, a winter visitor that has taken up residency in the arboreal beauty spots of Scotland and northern England. His beak is designed like a twisty corkscrew for popping pine kernels and not for serenading the green lady Crossbills, so his vocal repertoire is restricted to an occasional 'chup-chup'. He's got the scarlet jacket and the multipurpose beak, but you can't have it all.

Starling
Sturnus vulgaris

This scraggly, oily, unsociable gang member is actually one of the most gifted of our songbirds. With all manner of high-pitched peeps and chirps, curious knocks, rattles and buzzes, the Starling provides a constant supply to the white noise of everyday life. Like only a small pawful of UK birds, it's with the Myna bird-like wizardry of mimicry that the underdog Starling truly becomes a Great British star. With an ear for other tunesmiths he can imitate the House Sparrow, Lapwing, car alarms, telephones, and does a cracking Blackbird. An abhorred nuisance and a righteous, bona fide polymath of birdsong.

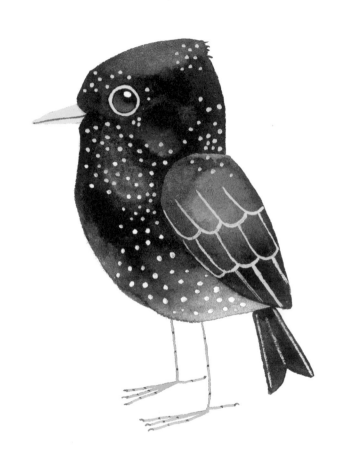

SPOTTING AND JOTTING

It's great spotting a bird you've never seen before, so here's a handy way of keeping all your jottings in check. Get spotting either by sitting comfortably at your window, or pull on some boots, grab a flask and binoculars, and go outside. Happy spotting!

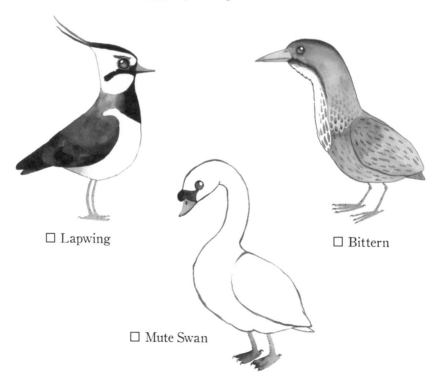

☐ Lapwing

☐ Bittern

☐ Mute Swan

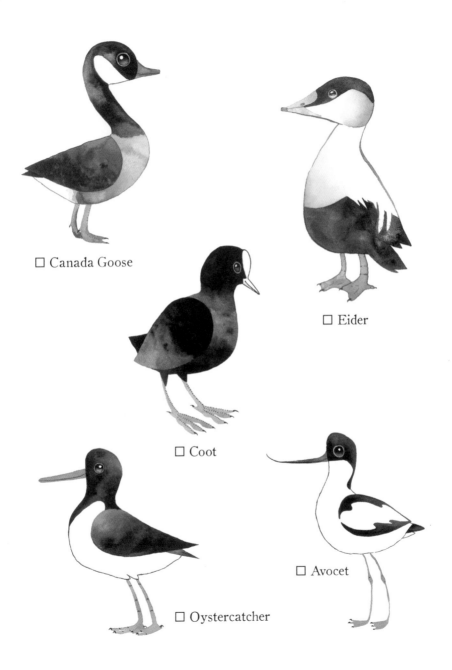

☐ Canada Goose

☐ Eider

☐ Coot

☐ Oystercatcher

☐ Avocet

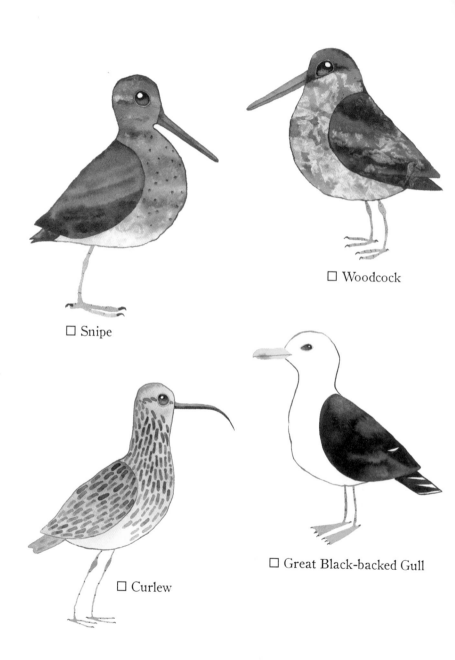

☐ Snipe

☐ Woodcock

☐ Curlew

☐ Great Black-backed Gull

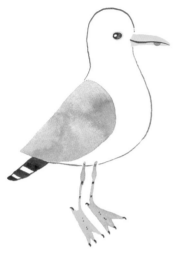

☐ Herring Gull

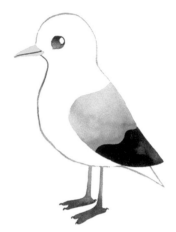

☐ Kittiwake

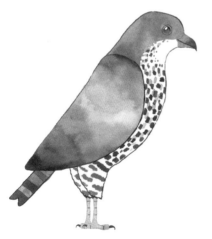

☐ Honey Buzzard

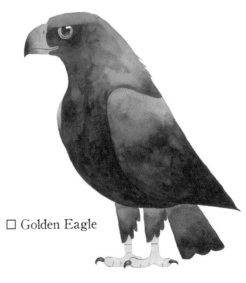

☐ Golden Eagle

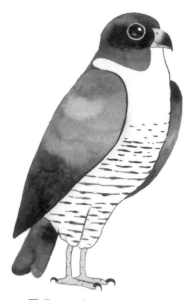

☐ Peregrine Falcon

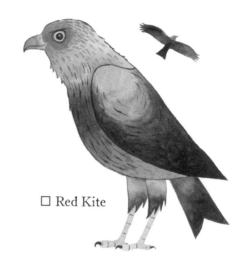

☐ Red Kite

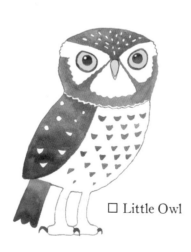

☐ Little Owl

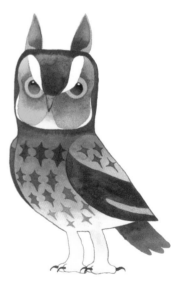

☐ Long-eared Owl

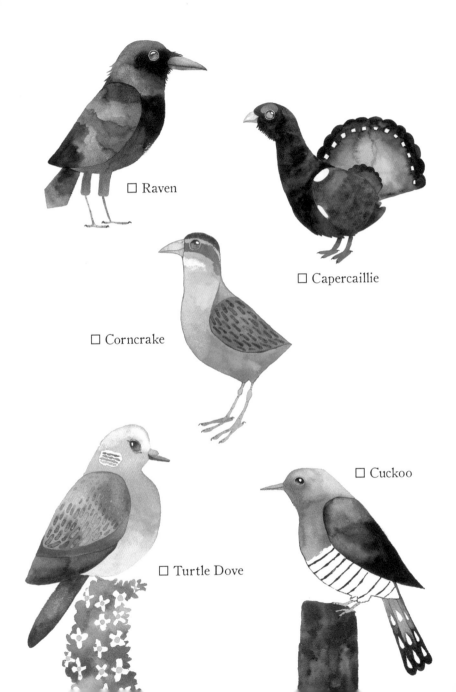

☐ Raven

☐ Capercaillie

☐ Corncrake

☐ Cuckoo

☐ Turtle Dove

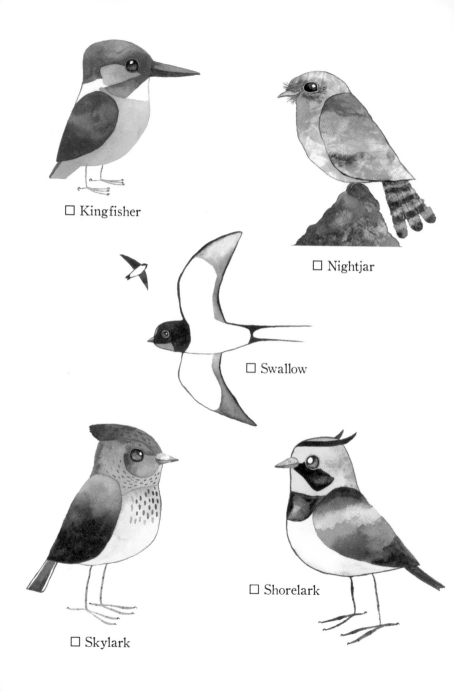

☐ Kingfisher

☐ Nightjar

☐ Swallow

☐ Skylark

☐ Shorelark

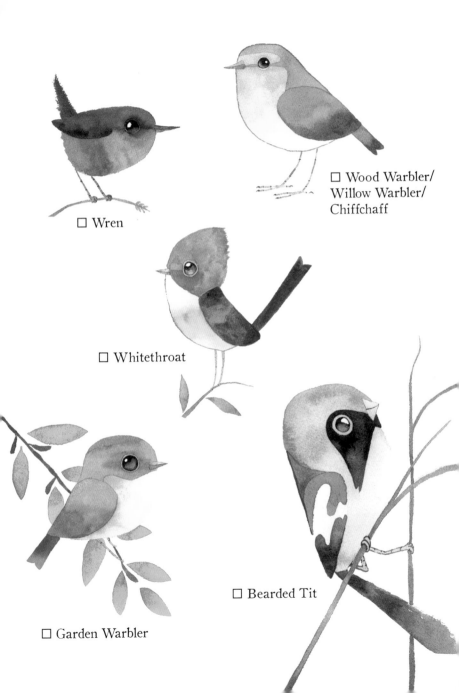

☐ Wren

☐ Wood Warbler/
Willow Warbler/
Chiffchaff

☐ Whitethroat

☐ Garden Warbler

☐ Bearded Tit

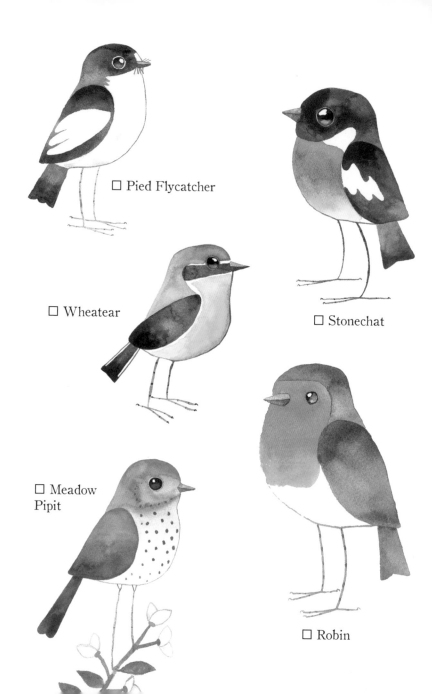

☐ Pied Flycatcher

☐ Stonechat

☐ Wheatear

☐ Meadow Pipit

☐ Robin

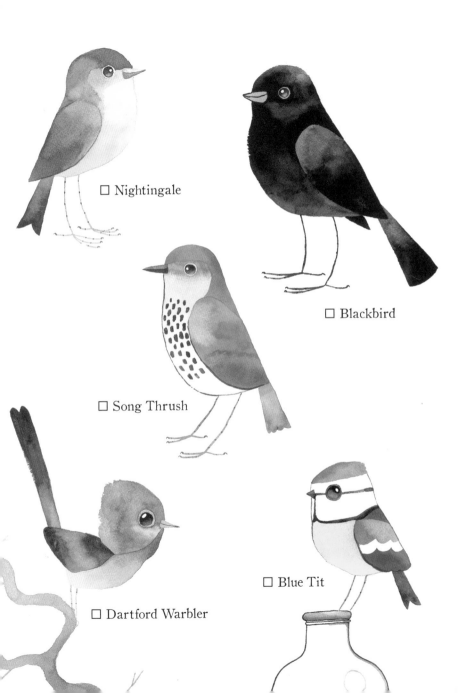

□ Nightingale

□ Blackbird

□ Song Thrush

□ Dartford Warbler

□ Blue Tit

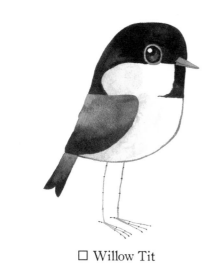

☐ Willow Tit

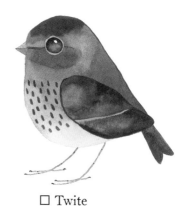

☐ Twite

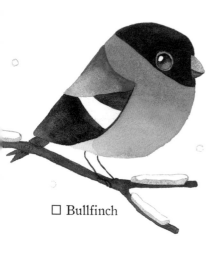

☐ Bullfinch

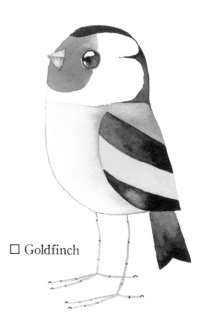

☐ Goldfinch

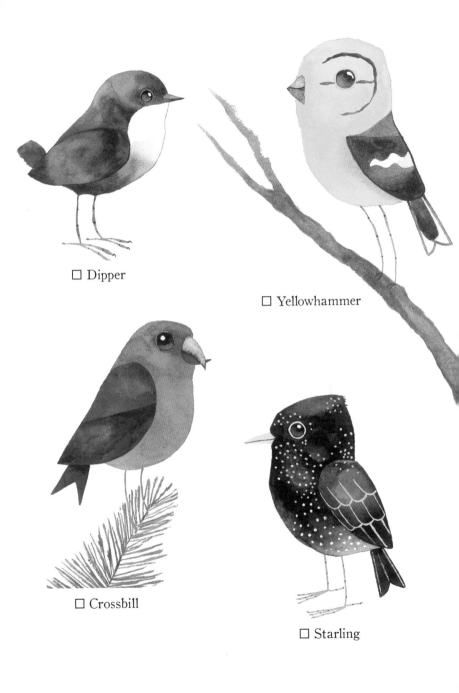

☐ Dipper

☐ Yellowhammer

☐ Crossbill

☐ Starling

ACKNOWLEDGEMENTS

Thank Yous.
The Goldfinches, for everything.
The Sewells, The Lees and The Roses.
Tim the Jay, Rob Avery, Graunty Christine and
her squeaky wheelbarrow. Jimi the Nuthatch.
Matthew the Horse's Kite fables, Simon
Benham, Matthew Clayton, Jeff, Andrew
and Robin at Caught by the River and the
Rooks at Heavenly.
The team at Gas as Interface, and all my
friends in London, Brighton, Shrewsbury,
Manchester and Melbourne!

Special big thanks to Adam and Meg, Leo,
Rach, Gaz, Matt and Jo, Ben and their families.
The Graunties, Me Tommo You Jane, Adam
and Nora, Desi and the Sims, Nick Fraser,
Danny and Joanne, Zenny, The Stones, Rich
and Cath, Ben and all at Spearfish, JK, Sam
Coxon, The Cranes, Em and Anthrax, Stevie
Neasden, Pinky, Lonny and Cosmo, The Flies,
Tom and Claire and The Marauder.

FOR BREW
FREAKS,
BEAN
GEEKS,
AND
THE
SIMPLY
CURIOUS ...

ROAST
GRIND
BREW
SERVE

IRELAND
INDEPENDENT
COFFEE
GUIDE

★★★★★★★★★

№1

Salt Media, 5 Cross Street, Devon, EX31 1BA.
www.saltmedia.co.uk
Tel: 01271 859299 Email: ideas@saltmedia.co.uk

Salt Media *Independent Coffee Guide* team:
Tadgh Byrne, Nick Cooper, Lucy Deasy, Kathryn Lewis,
Lisa McNeil, Tamsin Powell, Jo Rees, Rosanna Rothery,
Emma Scott-Goldstone, Christopher Sheppard, Dale Stiling,
Katie Taylor and Mark Tibbles.
Design, copy and illustration: Salt Media

**A big thank you to the *Ireland Independent Coffee Guide*
committee** (meet them on page 128) for their expertise
and enthusiasm, and to **our sponsors** Schluter, Cimbali,
KeepCup and Marco Beverage Systems.

Coffee shops, cafes and roasters are invited to be
included in the guide based on meeting criteria set
by our committee, which includes use of speciality
beans, a high quality coffee experience and being
independently run.

*All references to the Speciality Coffee Association of Europe (SCAE)
and the Speciality Coffee Association of America (SCAA) have been
changed to the Speciality Coffee Association (SCA) to reflect the
merging of the two organisations in January 2017.*

For more information on the Ireland, Scottish, South
West and South Wales, and Northern *Independent Coffee
Guides*, visit:
www.indycoffee.guide

🐦 @indycoffeeguide 📷 @indycoffeeguide

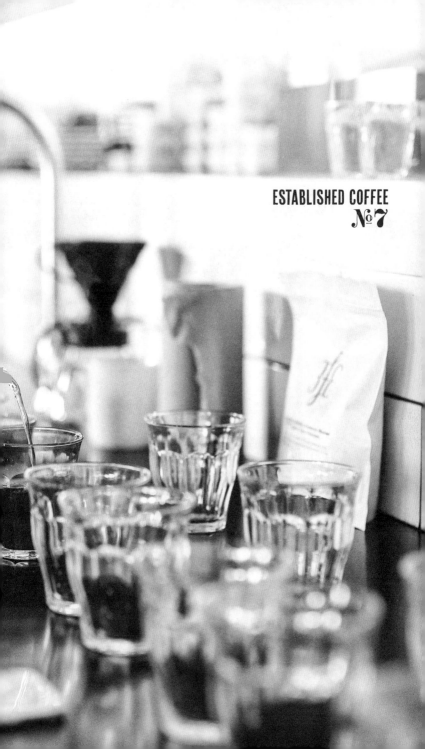

ESTABLISHED COFFEE
№7

CONTENTS

GENERAL MERCHANTS CAFE
№ 13

'IRELAND IS
EMBRACING
A SPECIALITY
REVOLUTION'

We've been writing about speciality coffee for a few years, and it feels fitting to release our first guide to speciality coffee in Ireland when the industry is at an all-time high.

Since our very first research trip (read: caffeinated blow out) in Dublin, a haul of new hangouts have joined the city's nexus of speciality shops, with Belfast's burgeoning coffee scene hot on its heels. Add to that the growing number of passionate roasters and baristas flying the flag for quality caffeine across the land and it's fair to say that Ireland is embracing a speciality revolution.

From nerdy nooks showcasing extraordinary single estates on the custom brew bar, to family run cafes serving top-notch espresso alongside all-day-eggs and avo-on-everything, you'll discover a venue for every sort of caffeinated occasion within these pages. There's also an inventory of the region's finest roasters included to ensure your home brew efforts hit the mark.

Not only is this our first guide for Ireland but it's my first as editor of the *Indy Coffee Guide* series. I hope you enjoy discovering Ireland's special coffee spots as much as I have.

Kathryn Lewis
Editor
Indy Coffee Guides

🐦 @indycoffeeguide
📷 @indycoffeeguide

5 THINGS
THE
COFFEE
PROS WISH
YOU KNEW

Ever wondered what the barista is really thinking when you place your particularly complicated order? Or what niggles the farmer who nourished those speciality beans?

We spoke to four insiders at different stages of the speciality chain to find out what they wished coffee drinkers knew ...

THE FARMER
DOROTHY HABONIMANA

LONG MILES COFFEE PROJECT, BURUNDI

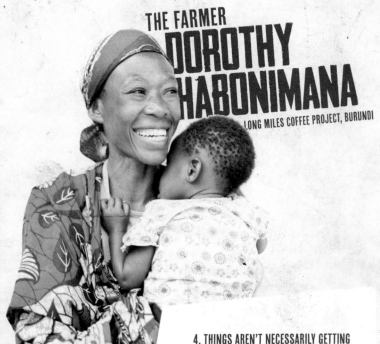

1. WE THINK OF YOU WHEN WE'RE GROWING COFFEE AND OFTEN WONDER IF YOU THINK OF US TOO

2. GROWING COFFEE IS LIKE RAISING A CHILD

We have to wash, nurture and look after our coffee plants, just like we look after our children.

3. COFFEE FARMING TAKES HARD WORK AND DILIGENCE

We mulch the ground and plant shade trees in order to grow better coffee. We even make small pools of rainwater with banana trees to make the ground moist for longer if needed.

4. THINGS AREN'T NECESSARILY GETTING ANY EASIER

New rules introduced by the government here in Burundi are making coffee growing more difficult for farmers like me.

5. THE COFFEE CHAIN

The income from the coffee you buy helps to pay for my six children's education.

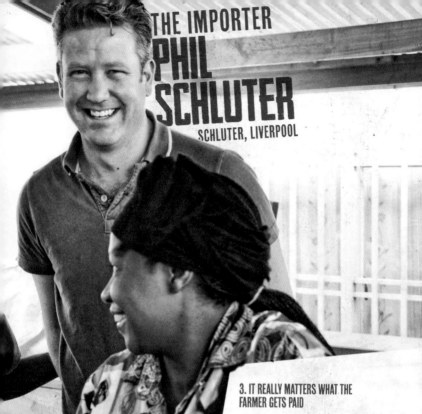

THE IMPORTER
PHIL SCHLUTER

SCHLUTER, LIVERPOOL

1. THE COFFEE SUPPLY CHAIN IS LONGER THAN MOST PEOPLE THINK

After harvesting, coffee needs to be pulped, fermented, washed, dried, milled, graded, hand-picked, bagged, labelled, cleared for export, trucked, shipped, stored, roasted, ground and finally, brewed.

2. IT'S NOT CHEAP TO MOVE SMALL VOLUMES OF COFFEE AROUND THE WORLD

The costs involved in getting coffee cherries from a farmer in an African village to your cup of coffee are high, with profit margins at each stage generally slim.

3. IT REALLY MATTERS WHAT THE FARMER GETS PAID

If you never ask, you'll never know, so please keep asking!

4. WE CUP HUNDREDS OF COFFEES EVERY WEEK TO IDENTIFY QUALITY AND VALUE

It can be hard work but it's also very exciting, especially on the occasions when we discover something truly special.

5. COFFEE IS GROWN IN SOME OF THE MOST BEAUTIFUL PLACES IN THE WORLD

It's an absolute privilege to visit farms and meet wonderful people living off the beaten track. We're always happy to take our clients along for the adventure, too. .

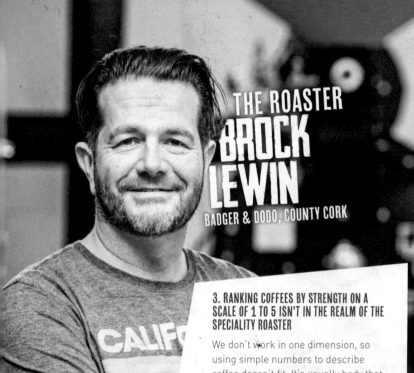

3. RANKING COFFEES BY STRENGTH ON A SCALE OF 1 TO 5 ISN'T IN THE REALM OF THE SPECIALITY ROASTER

We don't work in one dimension, so using simple numbers to describe coffee doesn't fit. It's usually body that customers are looking for when they talk strength, but coffee is so much more than body.

1. NOT ALL COFFEES FROM THE SAME COUNTRY TASTE THE SAME

So many factors affect the profile of a coffee and its country of origin may be the least influential in the cup profile. After all, it's simply a political boundary. If someone says they like a good Brazilian, we don't assume they're talking coffee.

4. HOME BREWERS CAN PLAY WITH THE PROFILE OF A CUP

The freshness of the coffee, grind time, grind size, water dose, infusion time and method of preparation all play a part in the resulting quality of the coffee.

2. ACIDITY IS NOT THE SAME AS BITTERNESS

People often get the two confused. Think of acidity as the vivacity that helps flavours sparkle and the aftertaste zing, whereas bitterness is anything done to excess – roast, grind or extraction – which creates a burnt, blunt flavour at the back of the tongue.

5. DIFFERENT ROASTERS ROAST DIFFERENTLY

If you come across the same coffee (same farm, estate and washing station, with the same processing method and varietal) from two different roasters, buy both and compare.

Feel Good
Do Good

THE WORLD'S FIRST
BARISTA STANDARD
REUSABLE CUP

KEEP IT & USE IT AGAIN

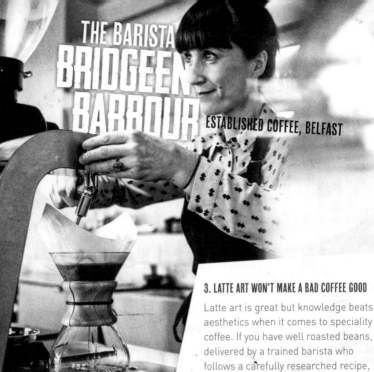

THE BARISTA
BRIDGEEN BARBOUR

ESTABLISHED COFFEE, BELFAST

3. LATTE ART WON'T MAKE A BAD COFFEE GOOD

Latte art is great but knowledge beats aesthetics when it comes to speciality coffee. If you have well roasted beans, delivered by a trained barista who follows a carefully researched recipe, an Instagramable rosetta is the cherry on top.

1. WHAT'S A PITCHER RINSER?

The coffee profession is a fairly recent one, so much of the language used is new. The first time you go behind a bar and someone asks you to clean the pitcher rinser and you look at them blankly, remember it's ok not to know. A great team will help you work it out.

2. QUALITY, QUALITY, QUALITY

From seed to cup, the picking and sorting of only the ripest cherries, the care in processing, the skill of roasting, the preparation and ability of the barista – which includes connecting with customers as well as skill with the coffee – all contribute to the experience of speciality.

4. FAST, FRIENDLY SERVICE

A professional barista should be able to hold a conversation and keep the line moving. You can't underestimate how much customers like feeling part of the scene but they also have to get to work.

5. THE POSSIBILITIES ARE ENDLESS

If I had known how much there was to explore, I would have taken the risk to join the world of speciality much sooner. From daily interactions with customers to working with amazing people, it's very special and puts me in a position to introduce some of the best coffees in the world to our customers.

TOUR DE SPECIALITY

NORTHERN TOUR

ROAD TRIP

DUBLIN TOUR

Take a break from Dublin's pub crawls, Belfast's history trips and surf tours of the coast. It's time to discover Ireland's thriving speciality scene with a caffeinated voyage around the Emerald Isle

DUBLIN
TOUR

THE ROUTE A mecca for coffee disciples around the world, join the caffeine congregation sampling Dublin's speciality offering. Whether you're sticking to the city centre, or venturing out to the suburbs, there are venues of varying size and nerdiness to satisfy all levels of coffee curiosity.

PACKING ESSENTIALS A pen to scribble down new finds in the notes section of your *Indy Coffee Guide* will avoid any head scratching later, plus a phone charger to keep your foodie followers snap happy. A bit of pocket money to pick up some new coffee kit along the way wouldn't go amiss either.

FUEL THE JOURNEY Brunch is a big deal in Dublin; get ready for poached eggs, smashed avo and cinnamon buns for breakfast, lunch and dinner.

EASE 10/10 We reckon the amount of speciality coffee sunk in the city rivals that of Guinness, so you're not going to be short of stops. Pack your copy of the *Indy Coffee Guide* and navigate the city one silky flat white or lip-smacking filter at a time.

NORTHERN
TOUR

THE ROUTE Hot on the heels of Dublin's cafe culture, Belfast's burgeoning speciality scene is worth a break across the border.

PACKING ESSENTIALS Channel your inner eco warrior and pack a KeepCup. A canvas shopper to carry your haul of beans picked up en route is another handy addition.

FUEL THE JOURNEY Sugar-free followers beware; carby treats are a diet staple when coffee shop hopping across this sweet city. Start the day with a stack of mascarpone-topped brioche french toast at The Pocket before pairing a next level caramel square with a mean filter from Bailies at District. And no tour would be complete without a slice stop at Established Coffee - its pie of the day has quite the cult following.

EASE 8/10 Stick to the city and you'll do just fine with a coffee map and a keen nose for good caffeine. If you want to explore some of the beauties outside of Belfast – take Haptik in Newtownards and Hollys Coffee Co. in Ballynahinch for instance – a friend with a car will come in handy.

ROAD TRIP

THE ROUTE Starting from Dublin, cruise down the M7 – stopping off at Joe's at Kildare Village – to the M8. Make a detour to Blackfriars and Portico in Waterford City if you fancy a trip to the coast, or carry on to Cork where you'll find Dukes, Three Fools, Warren Allen and Filter among other speciality spots. From here you can skim around the coast to Bean in Dingle or make waves to Galway and give the guys at Coffeewerk + Press a visit.

PACKING ESSENTIALS An AeroPress and portable grinder will be your saviour when it comes to motorway services – just make sure to stock up on quality beans at your first stop.

FUEL THE JOURNEY Homemade seasonal soups and doorstopper slices of cake acquired at the cafes should keep you going between each stop. If you're packing a big appetite, stock up on artisan goodies such as chocolate and sourdough too.

EASE 5/10 This one will take a bit of forward planning but discovering one-of-a-kind coffee shops in some of the country's most amazing locations will be worth any heated back-seat-driver discussions.

COFFEE
AND
FOOD
PAIRING?
It's complicated

QUIZZING THE Q GRADER

Ever wondered why devouring a slab of chocolate cake alongside your mid-morning coffee is so satisfying? Or found yourself agonising over which coffee will go best with your avo and feta smash? We asked Jan Komarek, Q grader and green bean buyer at Belfast's Bailies Coffee Roasters for his view

IS THERE A REASON WHY SO MANY PEOPLE ENJOY A SWEET TREAT WITH THEIR COFFEE?

We are very sensitive to the bitterness that is present (to a certain extent) in every coffee. That's because, for our ancestors living two million years ago, a bitter taste was closely associated with something poisonous. Nowadays we are much more accustomed to bitterness, but even relatively small amounts of bitter compounds can feel challenging to drink or difficult to enjoy. That's why people like to complement it with comforting sweetness which, in the past, was mainly associated with foods that are ripe and nutritious.

WHAT ARE THE RULES FOR PAIRING COFFEE WITH FOOD?

For good food and coffee pairings you need to look for a harmonious balance in taste, and synergy of flavours at the same time. Although there are basic guides to pairing, some of the most beautiful combinations deny all of them. Every great coffee has unique characteristics and should be paired based on that. So I don't believe in general rules and cheat sheets for pairing. Statements like 'all Sumatran coffees pair well with brownies' assume that all Sumatran coffees taste alike, which is true for commodity coffee, but not speciality.

ARE WE LIKELY TO SEE MORE FOOD AND COFFEE PAIRINGS ON MENUS?

Maybe. I hope we'll see even more people celebrating the different flavours in coffee. I feel that there are similarities with wine. The most widespread wine and food pairing took place when most people believed that there were a few simple rules to follow. Once this myth was debunked, a lot of people lost interest in it.

ARE THERE ANY FOOD AND COFFEE PAIRINGS THAT EVERYONE WOULD AGREE WITH?

The only thing I know that pairs well with all coffees – regardless of flavour, body or acidity – is good company.

BARISTA PAIRINGS

The flavour profile of a coffee, when matched with similar notes in food, can become the gateway to appreciating speciality coffee, says Mark Byers, head barista at Bridewell in Donaghadee

'Customers who are buying coffee often question what the purpose of the flavour notes is, some presuming that roasters have added dried fruit or chocolate to the coffee, or worse, artificial flavourings,' Mark explains.

At Bridewell's regular food and coffee pairing events, the team rustles up several delectable dishes, each one reflecting the flavour notes of a particular roast.

'By consuming food and coffee at the same time, we're indirectly training our palates to look out for particular flavours,' says Mark, who first tried out the concept on his own staff.

'The penny dropped and a real interest in a further understanding of speciality coffee was born,' he says. 'As for our customers, we've found that after our pairing events, they leave with a greater understanding of flavour notes and a confidence in purchasing coffee they'll enjoy.'

'BY CONSUMING FOOD AND COFFEE AT THE SAME TIME, WE ARE INDIRECTLY TRAINING OUR PALATES TO LOOK OUT FOR PARTICULAR FLAVOURS'

CHECK OUT A FEW OF MARK'S FAVOURITE MATCHES, WHICH USE FOOD TO DISTINGUISH FLAVOURS IN DIFFERENT COFFEES...

- THUNGURI AA -
KENYA

CLIMPSON & SONS

Flavour notes

POMEGRANATE, PLUMS AND DEMERARA SUGAR

Pairing

PLUM AND POMEGRANATE SORBET

■■■

- MUSASA -
RWANDA

TALOR & JØRGEN

Flavour notes

LIME AND NECTARINE

Pairing

LIME AND POLENTA CAKE WITH NECTARINE DRIZZLE

■■■

- LAS MARIAS -
NICARAGUA

ASSEMBLY

Flavour notes

RIPE CHERRIES AND HAZELNUT PRALINE

Pairing

DARK CHERRY CHEESECAKE WITH HAZELNUT PRALINE BASE

- ARAMO YIRGACHEFFE -
ETHIOPIA

ROOT & BRANCH

Flavour notes

SLOE GIN, BLACKBERRIES AND BLUEBERRIES

Pairing

ARAMO BRAMBLE COCKTAIL
(FRESH BLUEBERRIES, BLACKBERRY LIQUEUR AND COPELAND SPIRITS' RHUBERRY GIN)

■■■

- EL LIMONAR -
GUATEMALA

BAILIES COFFEE ROASTERS

Flavour notes

APPLE PIE AND PINEAPPLE

Pairing

CANDIED APPLE AND PINEAPPLE TARTLET

■■■

- LA CRISTALINA -
COLOMBIA

MAUDE COFFEE ROASTERS

Flavour notes

SWEET ORANGE, HIBISCUS AND HONEY

Pairing

HONEY INFUSED HIBISCUS BERRY AND ORANGE ICED TEA

YOUR
JOURNEY
STARTS
HERE

WEST CORK COFFEE
№ 117

Rwanda - Nkora

Red Bourbon - Washed

Sweet Orange/Cloves

WCC
West Cork Coffee

CAFES

Coffee shops and cafes where you can drink top-notch speciality coffee. We've split the whole of Ireland into areas to help you find places near you.

ROASTERS

Meet the leading speciality coffee roasters in Ireland and discover where to source beans to use at home.

MAPS

Every cafe and roaster has a number so you can find them either on the area map at the start of each section, or on the detailed city maps of Dublin and Belfast.

FINALLY

Discover MORE GOOD CUPS and MORE GOOD ROASTERS at the end of each section.

WWW.INDYCOFFEE.GUIDE

Don't forget to let us know how you get on as you explore the best speciality cafes and roasters:

🐦 @indycoffeeguide 📷 @indycoffeeguide

CAFE

5A
№10

NORTHERN
IRELAND

MIDDLE TOWN COFFEE CO
№ 2

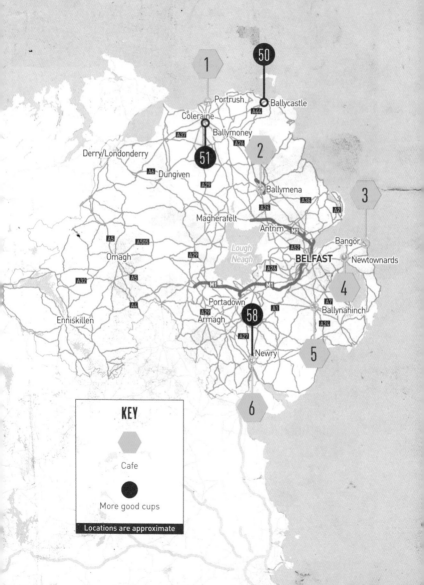

Portrush

50

Ballycastle
A44

1

Coleraine
A37

Ballymoney
A26

Derry/Londonderry

51

2

Dungiven
A6

A29

Ballymena

3

Magherafelt

A26

A36

A2

Antrim
M2

Omagh

A5
A505

A29

Lough
Neagh

A52

Bangor

BELFAST

Newtownards

A32

A5

M1

M1

A26

4

Portadown

A1

Ballynahinch
A7

Enniskillen

A4

Armagh

58

A24

A29
A27

5

Newry

6

KEY

Cafe

More good cups

Locations are approximate

№1. BABUSHKA KITCHEN CAFE

South Pier, Portrush, BT56 8DG.

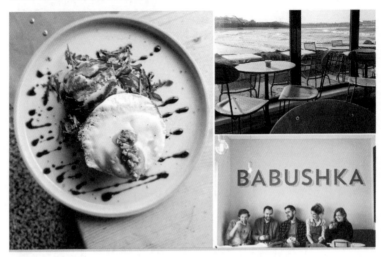

For a bracing spot of Atlantic storm-watching in winter or breakfast on the sunny seaside terrace in summer, Babushka is a much loved spot with Portrush locals – and rightly so.

As alluring as its siren namesake are Babushka's bacon and poached eggs with pancakes and maple syrup, the buttery homemade pecan pie and the lush stacks of contemporary cafe brunch faves (think avo, eggs, tomatoes, sourdough et al).

Of course all good grub needs a partner in crime and in this case it's Swedish Koppi coffee (as well as a variety of European guests such as Tim Wendelboe and Workshop), which is available as the house 'phat white', Kalita pourover and AeroPress. You can also buy Koppi beans to take away for home brewing.

INSIDER'S TIP GREAT GRUB IS SERVED ON A CUSTOM RANGE OF BEAUTIFUL ADAM FREW CERAMICS

The perfect excuse for a blast of sea air and to get some sand between your toes, visit this newly refurbished beach-side beauty for the all-day brekkie crafted from local produce. You can also join the crew for themed evenings such as beer and cheese pairings and Moroccan suppers and watch the sun go down over the water through the large picture windows.

KEY ROASTER
Koppi

BREWING METHODS
Espresso,
Kalita Wave,
AeroPress

MACHINE
La Marzocco Linea
PB ABR

GRINDERS
Nuova Simonelli
Mythos One,
Mahlkonig EK 43

OPENING HOURS
Mon-Sun
9.15am-5.30pm

 Gluten FREE

 COFFEE BEANS AVAILABLE

 ALTERNATIVE MILK

 WIFI

 CYCLE FRIENDLY

 OUTDOOR SEATING

 FAMILY FRIENDLY

 DISABLED ACCESS

BRING YOUR OWN Cup

T: 07787 502012

f Babushka Kitchen Cafe 🐦 @babushkafoods 📷 @babushkaportrush

№2. MIDDLETOWN COFFEE CO

60 Mill Street, Ballymena, Co. Antrim, BT43 5AF.

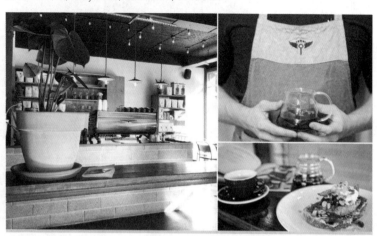

Pushing the boundaries of great service is the top priority for the crew at contemporary Middletown Coffee Co.

'We want our customers to have an experience – not just a run-of-the-mill coffee or meal,' say owners Johnny and Emma Hickinson.

Working with local farm shops, the cafe lures punters with fresh, clean and seasonal dishes – albeit with a few wicked indulgences thrown in.

'We were first inspired by the great cafes we encountered on a family vacation to Australia,' says Johnny who, after a stint at Established Coffee in Belfast, decided to introduce speciality coffee with good food to his home town of Ballymena.

INSIDER'S TIP BLISS OUT ON FRENCH TOAST WITH ORANGE AND CARDAMOM MASCARPONE, WHITE CHOCOLATE GANACHE AND PISTACHIO CRUMB

A year and a half later and Dublin roaster 3fe provides a consistently great house coffee, while guest roasts from Workshop Coffee, Roasted Brown and Square Mile add variety for caffeine fiends.

The Friday cupping sessions are as popular with teenage customers as they are with the over 60s. *'It makes us so happy to change someone's day or their mood through a great coffee experience,'* adds Emma.

KEY ROASTER
3fe

BREWING METHODS
Espresso, V60

MACHINE
Victoria Arduino
Black Eagle

GRINDERS
Nuova Simonelli
Mythos,
Mahlkonig EK 43

OPENING HOURS
Mon-Sat
8.30am-5.30pm

 Gluten FREE

 COFFEE BEANS AVAILABLE

 ALTERNATIVE MILK

 WIFI

 CYCLE FRIENDLY

 FAMILY FRIENDLY

 DISABLED & ACCESS

 COFFEE COURSES AVAILABLE

www.middletowncoffee.co T: 02825 648718

f Middletown Coffee Co. 🐦 @mtowncoffee 📷 @mtowncoffee

№3. BRIDEWELL COFFEE & PROVISIONS

19 High Street, Donaghadee, Co. Down, BT21 0AH.

After looking longingly for years at the abandoned space across from his ice cream parlour, Jonathan Foster finally opened the speciality shop he'd dreamed of at number 19 in October 2016.

Completely renovating the listed building which stood empty for over 20 years, Donaghadee's High Street is now home to a cool coffee-house-come-eatery.

Soon after opening, Jonathan brought barista Mark Byers on board, who leads the gaggle of coffee curators working wonders with the shop's exclusively single origin selection. Six months on, locals still swing by to see what's been done with the space, which is, says Mark: 'an opportunity to win over new, quality coffee converts.'

INSIDER'S TIP
SWING BY ON SATURDAY MORNING FOR A COFFEE AND A LOAF FROM LOCAL BAKERS, THE FROTHY WHISK

Cupping is a community occurrence here, with a bimonthly filter club blind tasting a selection of coffees from new guest roasters to decide which two have earned a residency on the grinder. Regular supper clubs are also on Bridewell's busy social calendar, as are live roastings from local indies such as Root & Branch, and coffee and food pairing evenings.

KEY ROASTER
Bailies Coffee Roasters

BREWING METHODS
Espresso, filter, cold brew

MACHINE
Kees van der Westen Spirit Duette

GRINDERS
Nuova Simonelli Mythos One, Mazzer Major

OPENING HOURS
Mon-Thu 9am-5pm
Fri-Sun 9am-6pm

 Gluten FREE
 COFFEE BEANS AVAILABLE
 ALTERNATIVE MILK
 WIFI
 CYCLE FRIENDLY
 FAMILY FRIENDLY

www.bridewellcoffee.com T. 07595 911711

f Bridewell Coffee 🐦 @_bridewell_ 📷 @bridewellcoffee

4. HAPTIK

29 Frances Street, Newtownards, Co. Down, BT23 7DW.

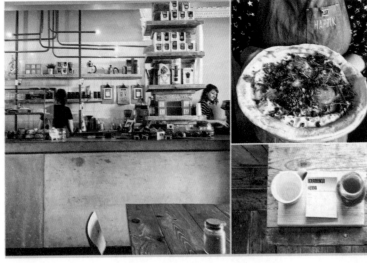

It was in Melbourne (surprise, surprise) that husband and wife team, Johnny and Rachel McBride fell in love with good coffee. After a year immersed in the city's art and caffeine culture – Johnny training as a barista, Rachel working in the creative scene – the pair weren't prepared to give up their speciality lifestyle when they returned to Newtownards in February 2014.

Fed up of travelling to Belfast for a good flat white, Haptik was born later that year as a community space in which to enjoy quality coffee, local art and great food.

On the ground floor, Johnny and his team of baristas compose beautiful brews from the copper-lined concrete bar, with drool-worthy brunch plates created in the little kitchen out back. Another floor up, Rachel curates a contemporary art space showcasing exhibitions by local and emerging artists.

INSIDER'S TIP: THE HUEVOS RANCHEROS ARE LEGENDARY BUT THE BAGHDAD EGGS ARE ALSO PRETTY SPECIAL

Belfast roaster Bailies provides the house blend which is crafted to liquid perfection on espresso, though you'll also find a striking selection of guest roasts from across the UK and Europe, which can be brewed as AeroPress or V60.

KEY ROASTER
Bailies Coffee Roasters

BREWING METHODS
Espresso, AeroPress, V60, french press

MACHINE
La Marzocco Linea

GRINDER
Nuova Simonelli Mythos One

OPENING HOURS
Mon-Sat
8.30am-5pm

www.wearehaptik.com T: 02891 821039

f Haptik 🐦 @wearehaptik 📷 @wearehaptik

№5. HOLLYS COFFEE CO.

20 Main Street, Ballynahinch, Co. Down, BT24 8UZ.

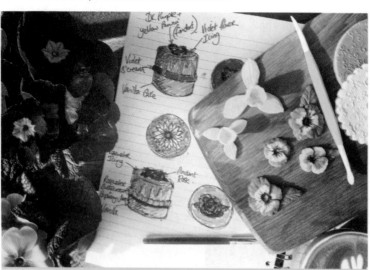

Luckily for us coffee snobs – not so luckily for our summer bods – top-notch coffee and gorgeous grub often come as a pair, though few are killing the combo and disgracing our diets quite as successfully as Hollys Coffee.

With two La Marzocco machines working wonders with the roll call of locally roasted Bailies beans, plus an in-house bakery pumping out a dozen different doughy delights and a line-up of bakes Mary Berry would be proud of, we'd recommend packing a healthy appetite on a trip to this Ballynahinch beauty.

INSIDER'S TIP **THE BANANA BREAD IS A BIG HIT WITH THE LOCALS. YOU MAY HAVE A FIGHT ON YOUR HANDS FOR THE FINAL SLICE**

Whether you're stopping by for a brunch of perfect poachies, getting stuck into a stuffed bagel or sampling 'the best scones in Belfast', the cluster of sociable baristas will find a quality coffee for the occasion. With guest roasters such as 3fe, The Barn and Root & Branch to play with on the brew bar, they've plenty to choose from.

A calendar of caffeinated events such as whiskey and coffee workshops and latte art throwdowns make the community cafe's social media pages worth a follow for updates.

KEY ROASTER
Bailies Coffee Roasters

BREWING METHODS
Espresso, drip filter, pourover, cold brew

MACHINES
La Marzocco GB5, La Marzocco Linea PB

GRINDERS
Mahlkonig EK 43, Mazzer Super Jolly Electronic Doser

OPENING HOURS
Mon-Tue 8am-4pm
Wed-Sat 8am-5pm

www.hollyscoffeeco.com 02897 228070

Hollys Coffee Co. @hollyscoffeeco @hollyscoffeeco

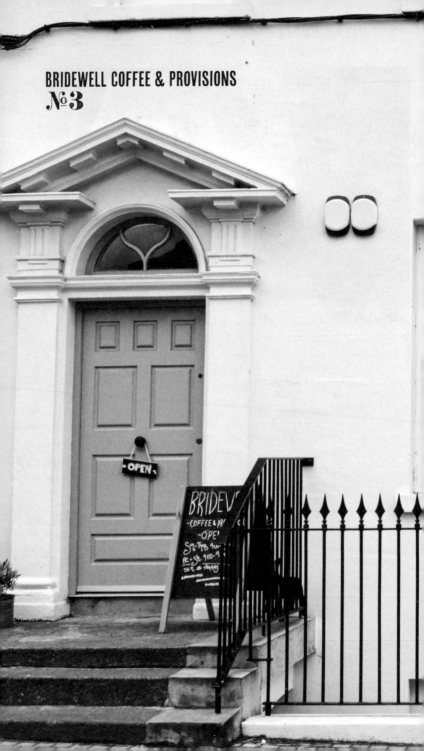

6. FINEGAN & SON

9 Kildare Street, Newry, Co. Down, BT34 1DQ.

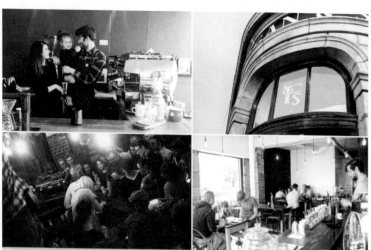

From barista jams to cheese tastings, cupping events to live music evenings, it's all go at this super friendly speciality shop.

Every member of the family – whether that's business partners Annemarie and Graeme, or son James who you'll often spy behind the bar – has a say in what appears in the hopper and on the menu.

Occupying one of Newry City's most recognisable buildings, the interior is modern with an industrial vibe, revealing the building's history – it's been a bakery, bar and spirit merchant in former lives – through original beams, stonework and floorboards.

INSIDER'S TIP MAKE A SATURDAY TRIP FOR HAND-ROLLED DOUGHNUTS FROM ANNEMARIE

Park yourself on a salvaged school chair and get stuck into a slice of lime and polenta cake while exploring one of the micro lot coffees. A different guest from a roster of both European and regional roasters (such as Tim Wendelboe and Cloud Picker) has featured every week since the cafe opened in 2016.

The full food menu offers lots of goodies, from breakfast faves to stonking burgers, while hot chocolate made from stoneground, single origin cocoa is a find.

KEY ROASTER
Bailies Coffee Roasters

BREWING METHODS
Espresso, V60, AeroPress, Chemex

MACHINE
La Marzocco GB5

GRINDER
Mahlkonig EK 43

OPENING HOURS
Mon-Sun
8am-5pm

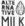

T: 02830 257141

f Finegan & Son 🐦 @fineganandson 📷 @fineganandson

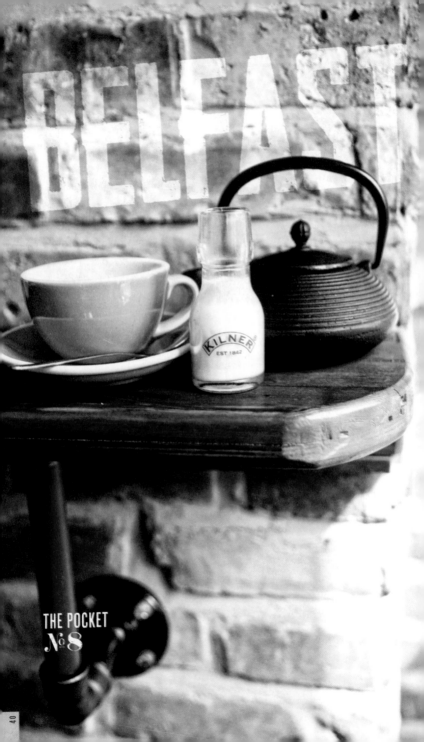

BELFAST

KILNER
EST 1842

THE POCKET
Nᵒ 8

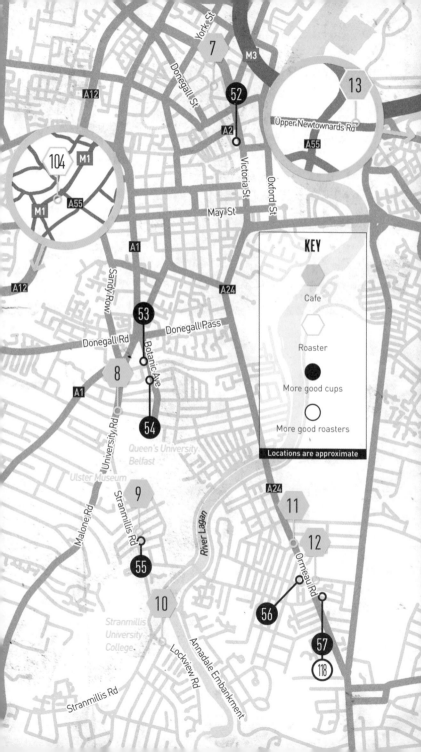

York St

7

M3

Donegall St

52

A2

13

Upper Newtownards Rd

A55

A12

Victoria St

Oxford St

104

M1

A55

M1

A12

May St

A1

A24

53

Donegall Pass

Donegall Rd

Botanic Ave

KEY

Cafe

Roaster

More good cups

More good roasters

Locations are approximate

8

A1

University Rd

54

Queen's University
Belfast

Ulster Museum

9

River Lagan

A24

11

12

Malone Rd

Stranmillis Rd

55

Ormeau Rd

10

56

Stranmillis
University
College

Lockview Rd

Annadale Embankment

57

118

Stranmillis Rd

BELFAST

7. ESTABLISHED COFFEE

54 Hill Street, Belfast, BT1 2LB.

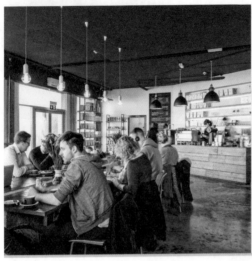

Talk to anyone in speciality about an upcoming trip to Belfast and the first thing they'll ask is, *'You're going to Established, right?'*

Since owners Bridgeen Barbour and Mark Ashbridge started slinging shots in 2013, the sleek cafe – tucked between the cobbled stones and street art of the Cathedral Quarter – has become an institution in the city. With a cluster of AeroPress and Barista Championship titles, plus a sophisticated selection of guest roasters alongside the 3fe mainstay, it's easy to see why.

INSIDER'S TIP: TAKE A CLASS IN ALL THINGS COFFEE AT THE NEW TRAINING ROOM

Whether you're sticking around at the communal benches to savour the matched espresso and cortado special chalked up on the custom board, or simply after a seriously good cappuccino, a band of zealous baristas is on hand to talk you through the options.

Established's edible masterpieces have gained a similar reputation; the pies in particular have become a bit of a thing. Check Instagram for daily specials, though we wouldn't recommend following if you've a tendency for food FOMO.

KEY ROASTER
3fe

BREWING METHODS
Espresso, Chemex, AeroPress, batch brew

MACHINE
Victoria Arduino Black Eagle Gravimetric

GRINDERS
Nuova Simonelli Mythos One, Mahlkonig EK 43

OPENING HOURS
Mon-Fri 7am-6pm
Sat 8am-6pm
Sun 9am-6pm

www.established.coffee T: 02890 319416

f Established Coffee @established @establishedcoffee

42

N₂ 8. THE POCKET

69 University Road, Belfast, BT7 1NF.

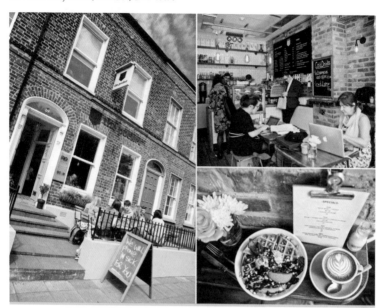

Q ueen's students struck it lucky when Richard Evans chose a pocket-sized spot on University Road for his first speciality coffee shop in the city.

If you do miss the cluster of canary yellow chairs and tables outside, the throng of flat white-wielding laptop warriors should lead you straight to the townhouse's vibrant front door.

INSIDER'S TIP THE POCKET'S (NOT SO) SECRET BASEMENT HOSTS BARE KNUCKLE BOXING MATCHES ON WEEKENDS

Inside, space is sparse – what else would you expect from a place called The Pocket? – however tables turn quickly and are worth tussling over when the brunch crowd swings by.

Stacked waffles and fruit-laden french toast make a sweet pairing to the 3fe espresso rocking the milk-based drinks, with healthy veggie and vegan bowls if you're eyeing up one of the doughnuts for dessert.

Behind the bar, there's a small selection of beans available to take home, as well as a line-up of speciality teas and award winning hot choc to enjoy in-store.

KEY ROASTER
3fe

BREWING METHODS
Espresso,
batch brew,
cold brew

MACHINE
Victoria Arduino
Black Eagle

GRINDER
Nuova Simonelli
Mythos One

OPENING HOURS
Mon-Fri
7.30am-5.30pm
Sat 9am-5pm
Sun 10am-4pm

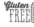 Gluten FREE

 COFFEE BEANS AVAILABLE

 ALTERNATIVE MILK

 WIFI

 CYCLE FRIENDLY

 OUTDOOR SEATING

 FAMILY FRIENDLY

 BRING YOUR OWN Cup

www.thepocket.coffee

f the pocket @thepocketcoffee @thepocketcoffee

№9. DISTRICT COFFEE – STRANMILLIS ROAD

82 Stranmillis Road, Belfast, BT9 5AD.

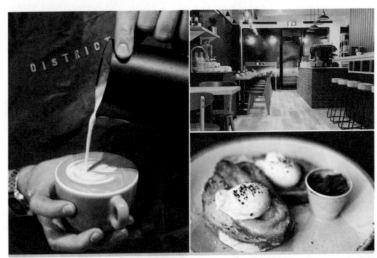

District's first coffee shop on Ormeau Road was such a hit with the city's brew buffs that mark II was launched just six months later.

Like the original cafe, the Stranmillis Road venue caters for every kind of coffee fan. 'We get a real mix of people,' enthuses director Richard, 'from parents with kids to young professionals and older couples. I love to see good food and great coffee bringing people together.'

Years of experience working alongside some of Belfast's best roasters and suppliers have earned Richard a penchant for speciality, 'I love the science behind coffee – you never stop learning about new trends and brewing methods,' he explains.

INSIDER'S TIP: GET STUCK INTO THE GREEN GODDESS: GRILLED CHEESE WITH AVO AND PESTO

This curiosity is expressed in the evolving filter menu which showcases roasters from across Ireland and further afield on V60. Local bean-baker Bailies provides the goods for the milk-based brews, while Belfast's Suki Teas offers a kooky collection of loose leaf infusions.

Breakfast, lunch and sweet treats also get the specialist treatment at this contemporary cafe, with a hefty selection of healthy, veggie and gluten-free options.

KEY ROASTER
Bailies Coffee Roasters

BREWING METHODS
Espresso, V60, cold brew

MACHINE
La Marzocco Linea PB

GRINDERS
Nuova Simonelli Mythos One, Mahlkonig EK 43

OPENING HOURS
Mon-Fri
8am-8pm
Sat-Sun
9am-8pm

www.districtcoffee.co.uk | 02890 683220

f District @districtbelfast @districtbelfast

No. 10. 5A

5a Lockview Road, Belfast, BT9 5FH.

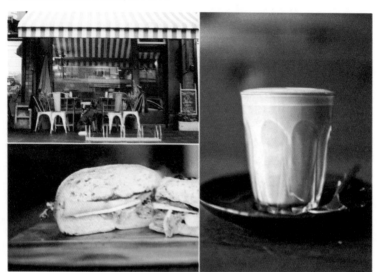

This tiny coffee shop in Stranmillis has become a favourite with Belfast's burgeoning brunch bunch. And a quick scroll through its Instagram feed – best avoided when hungry – reveals why.

The humble egg is king when it comes to all-day eating here, whether that's a crispy fried beauty topping roast garlic potato, leek and savoy hash, or golden poached yolks oozing over black pudding, grilled ham and local asparagus. A creamy scrambled number featuring feta and basil stuffed into a crumbly croissant also hits the sweet spot.

INSIDER'S TIP LOOK OUT FOR GUEST APPEARANCES ON FILTER FROM THE LIKES OF LOCAL ROASTER BAILIES

However you like your eggs in the morning, foodie picks are best paired with the latest masterpiece from the La Marzocco. The Barn takes care of the hopper's haul on espresso and batch brew, with retail bags available to take home too.

A laid-back and friendly atmosphere means everyone's welcome at this popular hangout, though you may have to fend off the league of local followers for one of the cosy tables inside or a seat from the cluster out front.

KEY ROASTER
The Barn

BREWING METHODS
Espresso,
batch brew

MACHINE
La Marzocco Linea
Classic 2 group

GRINDERS
Mahlkonig
Tanzania,
Nuova Simonelli
Mythos One

OPENING HOURS
Mon-Sat 8am-6pm
Sun 9am-6pm

T: 02890 687648

 5A Lockview Road 🐦 @5acoffee 📷 @5acoffee

Beyond the Bean Ltd.
1997-2017 Celebrating 20 years
of Drinking Thinking™

Proud sponsor of the Ireland Independent Coffee Guide

+44 (0)117 953 3522 // @beyondthebean

№11. GENERAL MERCHANTS CAFE – ORMEAU ROAD

361 Ormeau Road, Belfast, BT7 3GL.

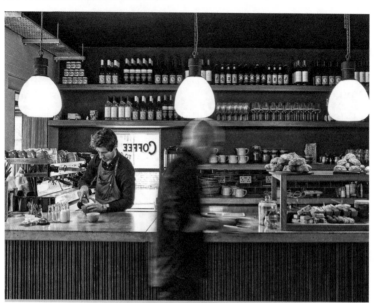

No two coffee hits at this sociable spot on Ormeau Road need be the same because if you're not feeling the batch brew from The Barn, the guest espresso changes daily.

Don't sweat if you do fall head-over-heels for whatever you discover in your cup, as most of the beans served at this prohibition-style cafe can be found in GM's well-stocked retail selection.

INSIDER'S TIP LOOK OUT FOR EUROPEAN ROASTERS SUCH AS FJORD, APRIL AND ESPRESSO MAFIA ON GUEST

Swing by after 11.30am and it's not just pure caffeine and good vibes the friendly team is dishing out. Ultimate weekend goals come in the form of craft beers and wines, best imbibed with a dish from the all-day brunch menu. A similarly impressive evening offering warrants a same-day return trip.

A mismatch of roomy tables, a string of stools in the window and a takeaway hatch serving speciality to the street means that however busy this bustling hangout becomes, you'll be able to get your flat white or filter fix.

KEY ROASTER
The Barn

BREWING METHODS
Espresso, batch brew, cold brew

MACHINE
La Marzocco Linea PB

GRINDER
Nuova Simonelli Mythos

OPENING HOURS
Mon-Tue
8am-6pm
Wed-Sat
8am-11pm
Sun 9am-6pm

www.generalmerchants.co.uk T: 02890 291007

f General Merchants 361 @genmerch361 @generalmerchants361

12. DISTRICT COFFEE – ORMEAU ROAD

300 Ormeau Road, Belfast, BT7 2GE.

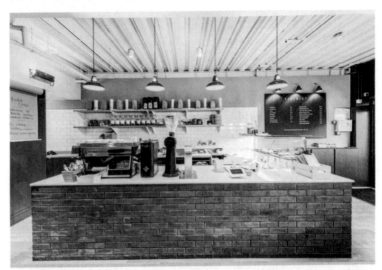

While District's Ormeau Road joint may channel a cool industrial vibe, it's a case of warm welcomes all round at this newbie on the Belfast coffee block.

Opened in October 2016 by David Rea and business partner Richard Stitt, the sociable spot is already a big hit with the city's coffee connoisseurs, as well as with busy mums, mainstream millennials and "grey wolves" looking for a top-notch brew and something tasty.

Rare and unusual micro lots brewed on V60 are the house speciality, and a constantly evolving line-up of beans means there's always something new to sample. Local roaster Bailies takes care of the espresso offering and you'll often find guest appearances from the likes of Man Vs Machine among a host of European faves.

INSIDER'S TIP
THE RAW, VEGAN MILLIONAIRE'S SHORTBREAD WILL TURN ANY DAIRY DEVOTEE

A colourful section of enticing salads and inventive sandwiches offers a refreshing alternative to the cafe brunch scene, with stacks of veggie, vegan and gluten-free options such as the killer courgette and feta quiche and the spicy black bean and guacamole quesadilla. *'We want all walks of life to feel welcome at District and try to reflect that in the food we serve,'* explains Richard.

KEY ROASTER
Bailies Coffee Roasters

BREWING METHODS
Espresso, V60, cold brew

MACHINE
La Marzocco Linea PB

GRINDERS
Nuova Simonelli Mythos One, Mahlkonig EK 43

OPENING HOURS
Mon-Fri
8am-5pm
Sat-Sun
9am-5pm

www.districtcoffee.co.uk T 02890 643603

f District @districtbelfast @districtbelfast

MAP 13. GENERAL MERCHANTS CAFE – UPPER NEWTOWNARDS ROAD

481 Upper Newtownards Road, Belfast, BT4 3LL.

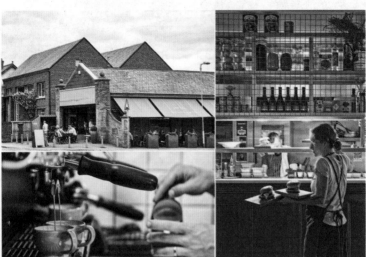

From foodies 'graming the gorgeous grub, to old friends meeting up over a brew, it's not just caffeine fiends that you'll be tussling with for a table at this bustling Belfast brunch spot.

Locals flock to General Merchants' original haunt for the badass breakfast – we're talking pork-belly topped toasted brioche with poached eggs and homemade hollandaise – and its drool-worthy dinners such as deep-fried chicken waffles with spring onion and Vegemite mayo. While coffee freaks congregate for the sweet selection of brews.

INSIDER'S TIP: WE WON'T JUDGE IF YOU RETURN THE SAME DAY FOR THE AWESOME EVENING MENU

Scouring the continent for incredible indie roasters and little-known beany beauties, its team of baristas is serious about showcasing the best coffee Europe has to offer – via espresso, batch and cold brew. Naturally then, you'll discover an ever-expanding roster of guest roasters behind the bar, including Roasted Brown, Fjord and Fortitude, alongside GM's mainstay from The Barn.

The grub changes as quickly as the guest brew, so make sure to get your fix of new faves while they last to avoid unnecessary menu mourning.

KEY ROASTER
The Barn

BREWING METHODS
Espresso,
batch brew,
cold brew

MACHINE
La Marzocco Linea

GRINDERS
Nuova Simonelli
Mythos x 2,
Mahlkonig EK

OPENING HOURS
Sun-Tue 8am-5pm
Wed-Sat
8am-10pm

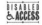
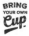

www.generalmerchants.co.uk T: 02890 652708

General Merchants Cafe @genmerchbelfast @generalmerchantscafe

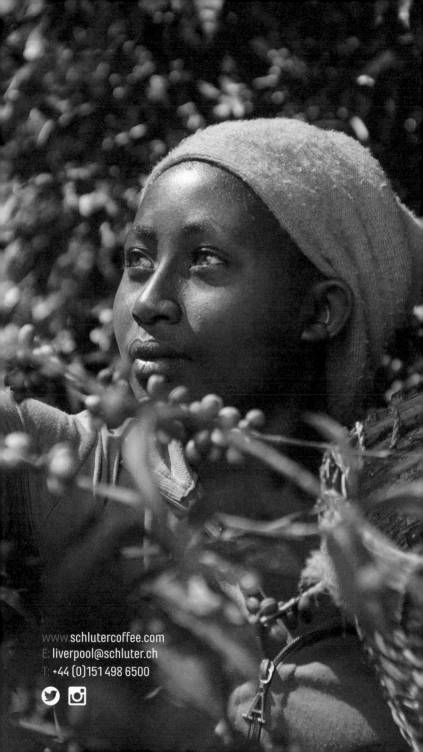

www.schlutercoffee.com
E: liverpool@schluter.ch
T: +44 (0)151 498 6500

SCHLUTER

SINCE 1858

Speciality green coffee suppliers

—— since 1858 ——

Purpose.
Passion.
Progress.

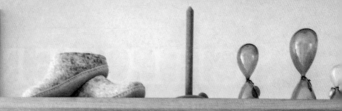

REPUBLIC OF IRELAND

COFFEEWERK + PRESS
Nᵒ 17

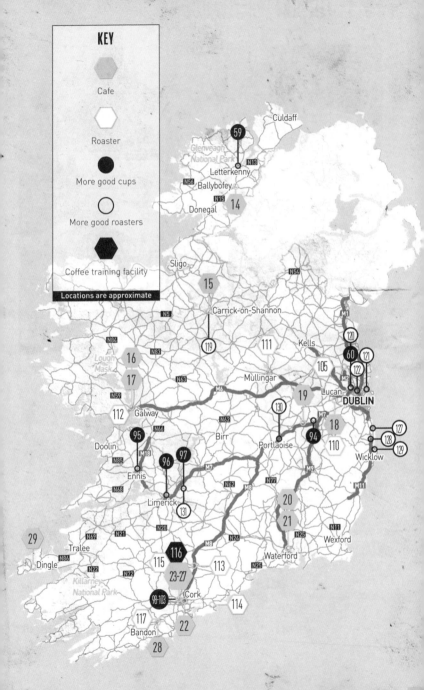

KEY

Cafe

Roaster

More good cups

More good roasters

Coffee training facility

Locations are approximate

Culdaff

59

Glenveagh
National Park

Letterkenny

N13

N56

Ballybofey

N15

Donegal

14

Sligo

N5

15

N54

Carrick-on-Shannon

111

Kells

N84

119

Lough
Mask

N83

16

N63

Mullingar

105

60

120

121

122

DUBLIN

17

M6

19

Lucan

N59

Galway

N66

Birr

130

18

110

127

112

95

N62

Portlaoise

94

128

129

Wicklow

Doolin

96

97

M7

Ennis

N85

M18

M7

N68

131

M9

M11

N62

Limerick

20

29

Tralee

N69

N21

N20

M8

N24

21

N25

Wexford

N86

N22

N72

115

116

113

N77

N11

Dingle

Killarney
National Park

23-27

Waterford

N25

Cork

114

98-103

117

22

Bandon

28

53

MAP.29

14. THE HATTER TEA ROOM

Meeting House Street, Stranorlar, Co. Donegal.

'We're all mad here!' is the refrain at this Stranorlar tea room and coffee house, although more correct would be to suggest that you'd be crazy not to visit.

Because with its recently launched own-brand beans, in-house barista training school, coffee subscription service and book club, this is clearly one to watch.

In addition to the Hatter beans, guest roasts from Irish Baobab and Berlin's The Barn are served in a wide variety of styles including Chemex, vacuum pump, V60 and moka pot.

INSIDER'S TIP WINNERS OF TWO CUSTOMER SERVICE AWARDS LAST YEAR, YOU'RE IN SAFE – AND FRIENDLY – HANDS

Not that tisane lovers are neglected, as the cracking selection of high-quality loose leaf teas testifies. And with a strong breakfast, lunch and afternoon tea (with lots of homemade cakes) offering, this Wonderland has 'eat me' and 'drink me' written all over it.

KEY ROASTER
Robert Roberts

BREWING METHODS
Espresso, moka pot, V60, french press, vacuum pump

MACHINE
Rancilio

GRINDER
Mazzer

OPENING HOURS
Mon-Thu 8am-6pm
Fri 8am-8pm
Sat 9am-6pm
Sun 10am-5pm

www.thehattertearoomcom T: 074 9175383

f The Hatter Tea Room 🐦 @hattertearoom 📷 @hattertearoom

15. CAFE LOUNGE SPECIALTY COFFEE AND TEA BAR

Unit 3, Mercantile Plaza, Carrick-on-Shannon, Co. Leitrim.

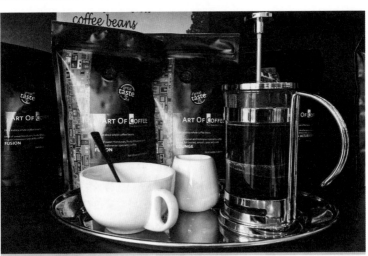

Even as a child, Georgia Visnyei was mad about coffee, as her Austro-Hungarian and Italian heritage immersed her in coffee culture from a young age.

'I remember as a child stealing the last few drops of coffee from my parents' cups. I loved the smell and I loved the taste – and I still can't get enough of it. So I'm thrilled to be running my own speciality coffee business.'

It was after losing her job in the recession that the former architect decided to build a business based on her passion for the mighty bean.

INSIDER'S TIP: TRY THE LOUNGE BLEND WHICH HOLDS A TWO STAR GREAT TASTE AWARD

'In 2009 I bought a tiny little roaster and started to roast coffee in my kitchen,' says Georgia.

From these humble beginnings she set up Cafe Lounge, a tastefully decorated emporium of superb coffees in Carrick-on-Shannon.

Coffee connoisseurs flock to get their fix of the award winning espresso from Cafe Lounge's own roastery, Art of Coffee, which hand-roasts beans with reverence at a nearby site, while tea fans enjoy a massive selection of fragrant tisanes.

KEY ROASTER
Art of Coffee

BREWING METHODS
Espresso, cafetiere

MACHINE
Futurmat

GRINDERS
Eureka, Mahlkonig

OPENING HOURS
Mon-Fri
9am-6pm
Sat-Sun
10am-6pm

www.cafelounge.ie T: 071 9650914

f Café Lounge - Carrick-on-Shannon @cafeloungecarrickonshannon

№16. BADGER & DODO

Fairegreen Road, Galway, Co. Galway.

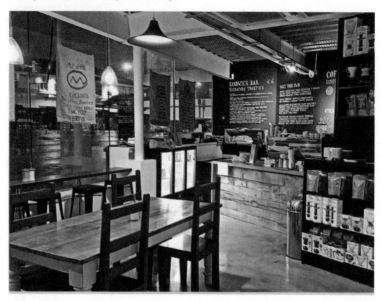

Galway's third wave followers hit the jackpot in 2014 when one of the country's top roasters chose this spot close to the bus and train station to open his first coffee shop. Three years of filters and feasting later and it's not just the city's coffee aficionados which Badger & Dodo is winning over.

INSIDER'S TIP: CURB A CAFFEINE OVERLOAD WITH A FRESHLY GRILLED RUEBEN - THE UNDISPUTED KING OF TOASTIES

Crafting the cafe's hefty selection of single origins from his County Cork roastery, Aussie owner Brock Lewin is keen to ensure the same care and precision that goes into the roasting process is maintained in the execution of the liquid nectar. Naturally then, you'll find some pretty knowledgeable baristas behind the vibrant black and orange bar, slinging shots and fashioning filters on the latest kit.

A coffee set is the way to go if you're looking for something specialist. Explore a particular origin via espresso and V60, or mix things up and compare two of your picks from the board on AeroPress. Any new fave finds are also available to take home in 250g bags.

KEY ROASTER
Badger & Dodo

BREWING METHODS
Espresso, Chemex, V60, AeroPress, Marco Über Boiler

MACHINE
La Marzocco PB

GRINDERS
Mahlkonig Peak, Mahlkonig EK 42

OPENING HOURS
Mon-Sat 8am-4pm
Sun 10am-4pm

 Gluten FREE
 COFFEE BEANS AVAILABLE
 ALTERNATIVE MILK
 WIFI
 CYCLE FRIENDLY
 OUTDOOR SEATING
 DISABLED ACCESS

www.badgeranddodo.ie T: 086 3380366

f Badger & Dodo Boutique Coffee Roasters @galwaybadger @badgeranddodo

17. COFFEEWERK + PRESS

4 Quay Street, Galway, Co. Galway.

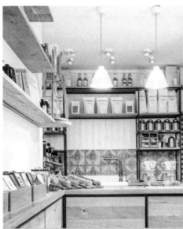

Overlooking the harbour at Galway Bay is the design-loving, coffee geek's dream find.

Describing itself as a 'space created to showcase the overlap between Irish and international design while exploring speciality coffee', this quirky spot is your go-to for aesthetic inspiration over a flat white.

The creative hub features artisan lifestyle goods and homewares such as high quality cosmetics made with foraged botanicals.

Coffee ingredients are equally eclectic with the house roast (nougat, caramel and chocolate notes) courtesy of Copenhagen's The Coffee Collective, served with milk from organic Jersey cows via The Village Dairy at Killeshin.

INSIDER'S TIP THE BEAUTIFULLY ILLUSTRATED TAKEAWAY CUPS ARE THEMSELVES WORTH COLLECTING

Guest roasts are a big deal here – they've featured about 16 to date from all over the world, including regular spots for Colonna in Bath and Proud Mary from Melbourne.

KEY ROASTER
The Coffee Collective

BREWING METHODS
Espresso, Kalita Wave, cold brew

MACHINE
La Marzocco Linea PB

GRINDERS
Mahlkonig EK 43, Mythos One x 2

OPENING HOURS
Mon-Thu
8.30am-6pm
Fri-Sun
9am-7pm

Gluten FREE

COFFEE BEANS AVAILABLE

ALTERNATIVE MILK

WIFI

CYCLE FRIENDLY

OUTDOOR seating

FAMILY FRIENDLY

DISABLED ACCESS

BRING YOUR OWN Cup.

COFFEE COURSES AVAILABLE

www.coffeewerkandpress.com T: 091 448667

f Coffeewerk + Press @coffeewerkpress @coffeewerkandpress

№18. BAOBAB COFFEE ROASTERS

92 English Row, Celbridge, Co. Kildare.

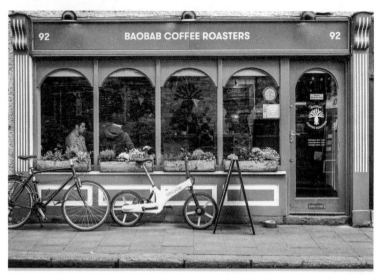

The roots of the Baobab coffee empire snake across the road from the historic Mill Centre – where the coffee is roasted – to its cafe on English Row.

And where they pop up has become a fertile site of coffee culture, providing the good folk of Celbridge with freshly roasted beans and speciality coffee inspiration from across the globe.

A diverse range of serve styles from immersion brew and pourover to cold brew is on hand to do justice to the coffee roasted by childhood friends and business partners Luigi Fanzini and Alex Thorpe, who were raised in Nairobi.

INSIDER'S TIP TAKE A PEEK THROUGH THE DOOR AT THE NEARBY ROASTERY TO SEE THE MAGIC IN ACTION

Well trained baristas, a friendly and authentic setting, and top quality beans are always a heady brew, but when you add handmade cakes, homemade ice cream and freshly grilled toasties, well, you could laze under this particular baobab tree all day.

KEY ROASTER
Baobab Coffee Roasters

BREWING METHODS
Espresso, Chemex, V60, immersion brew, AeroPress, cold brew

MACHINE
Kees van der Westen Speedster

GRINDERS
Mahlkonig K30, Mahlkonig Peak, Mahlkonig EK 43

OPENING HOURS
Mon-Sat 9am-6pm
Sun 10am-5pm

www.baobab.ie T: 01 6274440

f Baobab Coffee Roasters 🐦 @baobabroasters 📷 @baobabroasters

19. JOE'S COFFEE – KILDARE VILLAGE

Kildare Village, Nurney Road, Kildare, Co. Kildare.

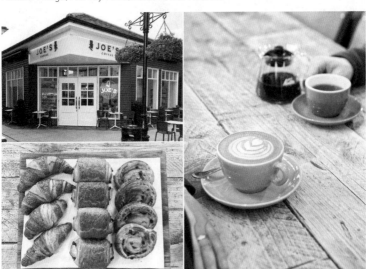

Joe's third venture into speciality; the Kildare Village venue is its first outside of Dublin. And, much like the flagship cafe at Arnotts, this one calls a busy retail hub its home.

Less than an hour from Dublin, the purpose-built shopping destination is a sale snooper's paradise, and with 90 boutiques to browse, shoppers will need to keep those caffeine levels topped up.

Though Joe's mainstay roast (via The Barn in Berlin) is always available, head of coffee, Mate Szekeres, works closely with 3fe so you'll often also find the Dublin roaster featured alongside a host of other European favourites.

INSIDER'S TIP: THE SHOP GETS ITS NAME FROM THE PHRASE 'CUP OF JOE' AS COINED BY SAILORS IN THE US NAVY

The spacious coffee shop was given a makeover in March 2017, lending the space a clean and bright feel with white walls and large windows. Equally fresh are the homemade soups which are best enjoyed with a stacked sarnie or hearty salad on the side.

Home coffee enthusiasts will also want to make a trip for the brewing paraphernalia. The staff – all qualified baristas – can advise on essential kit to pimp your set-up.

KEY ROASTER
The Barn

BREWING METHODS
Espresso, batch brew

MACHINE
Victoria Arduino Black Eagle

GRINDERS
Nuova Simonelli Mythos One, Mahlkonig EK 43

OPENING HOURS
Mon-Wed 10am-7pm
Thu-Fri 10am-8pm
Sat 9am-8pm
Sun 10am-8pm

www.joes.ie T: 045 520451

f Joe's Coffee, Dublin 🐦 @joesdublin 📷 @joesdublin

WE ♥
BREW
ING

№20. BLACKFRIARS COFFEE

4 Blackfriars, Waterford, Co. Waterford, X91 R253.

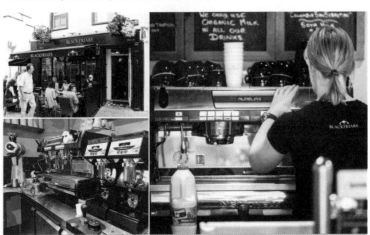

Adjoining medieval Blackfriars Abbey in the heart of Waterford City, this caffeine bolthole is a family affair. Run by sisters Kelly and Sarah with dad Donal, the snug coffee hub is somewhere to kick back and chill when you want to escape the bustling city centre.

Opened in 2014 with the goal of making consistently good coffee and providing great customer service, Blackfriars has a long association with Colin Harmon's 3fe beans, which the team crafts into gratifyingly good cups of espresso and filter.

Along the way, it's added a health-conscious menu of salads and sandwiches using ingredients from down-the-road producers. While the powerhouse breakfasts provide top nourishment for the day – the eggs benny avocado being a particular hit with loyal followers.

INSIDER'S TIP ORDER THE TOWER – A SUPER HEALTHY VERSION OF THE CLASSIC FRY UP

If you want to pick up some new skills from the band of baristas behind the La Marzocco, sign up to one of Blackfriars' homebrew training classes. And if you've no time to linger, swing by the newly opened espresso bar at TRM on Michael Street.

KEY ROASTER
3fe

BREWING METHODS
Espresso, V60, Kalita Wave

MACHINES
La Marzocco FB/70, Nuova Simonelli Aurelia

GRINDERS
Nuova Simonelli Mythos x 2, Mahlkonig EK 43

OPENING HOURS
Mon-Thu
8am-5pm
Fri-Sat
8am-6pm
Sun
10am-4pm

 Gluten FREE

 COFFEE BEANS AVAILABLE

 ALTERNATIVE MILK

 WIFI

 OUTDOOR SEATING

 BRING YOUR OWN Cup

COFFEE COURSES AVAILABLE

www.blackfriarscoffee.com T: 051 857615

f Blackfriars Coffee 🐦 @no4blackfriars 📷 @blackfriarscoffee

№21. PORTICO COFFEE

1 Peter Street, Arundel Square, Waterford, Co. Waterford.

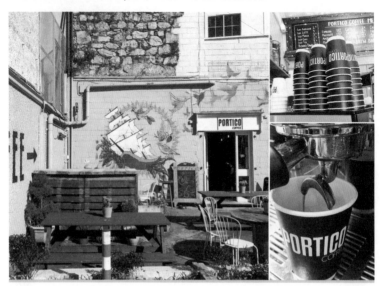

With a vibrant mural above the entrance and the word 'coffee' sprayed in huge letters on the adjacent wall, you'd be hard pushed to miss Waterford City's first third-wave coffee shop.

Inspired to create a cafe which cares as much about the quality of the coffee as its role in the local community, Portico was launched by a group of like-minded caffeine enthusiasts in 2012 to serve the people of Waterford.

Crafting up to twelve single origin brews from behind the bar at this petite coffee spot is a crack team of baristas, many of whom volunteer from the local church and give up their time to learn the trade.

INSIDER'S TIP — PAIR YOUR PICK ON V60 WITH A BROWNIE BAKED BY THE LOCAL AMISH COMMUNITY

Though it's not just budding baristas that the gang seeks to enlighten in all things speciality, stating: *'It's great to see our regulars, who wouldn't have been interested in the finer details, getting excited about the industry and picking up on the flavour notes in different beans.'*

KEY ROASTER
Badger & Dodo

BREWING METHODS
Espresso, V60, AeroPress, filter

MACHINE
La Marzocco Linea 2 group

GRINDER
Anfim Milano

OPENING HOURS
Mon-Fri 8am-5pm
Sat 9am-5pm

COFFEE BEANS AVAILABLE

ALTERNATIVE MILK

WIFI

CYCLE FRIENDLY

OUTDOOR SEATING

DISABLED ACCESS

BRING YOUR OWN Cup.

www.porticocoffee.com T: 085 1505121

f Portico Coffee 🐦 @portico_coffee 📷 @porticocoffeewaterford

22. DUKES COFFEE COMPANY – CITY GATE

The Plaza, City Gate, Mahon, Cork, Co. Cork, T12 CR23.

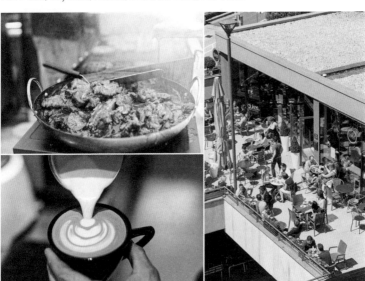

If the original Dukes in the city centre is a mecca for brunching families and caffeine fiends, its sister venue at City Gate is a sanctuary for Cork's coffee conscious professionals.

Right in the centre of the IT district, this contemporary cafe is primed and ready for the morning flat-white flurry with a band of energetic baristas and killer line-up of speciality roasters. While midday grub-to-go is taken care of via a roster of local producers.

A slick layout and contemporary design means service ticks over like a well oiled machine at this busy spot, while those who can afford a few minutes to linger over a filter will find plenty of space in which to get set up with a laptop or paperback.

INSIDER'S TIP GET YOUR CHOPS AROUND BANGERS FROM THE LOCAL BUTCHER, SERVED ON THE TERRACE ON WEDNESDAYS AND FRIDAYS IN SUMMER

In summer, head to the roomy terrace for a fruity cold brew and lunch alfresco – the chilli and lime chicken wrap, and smoked bacon, lettuce and tomato sarnie with house 'slaw on local sourdough are firm faves.

KEY ROASTER
Various

BREWING METHODS
Espresso, filter, cold brew

MACHINE
La Marzocco FB80

GRINDER
Mahlkonig K30 twin

OPENING HOURS
Mon-Fri
7.30am-5pm

www.dukes.ie T: 021 4350139

f DUKES Coffee Company 🐦 @dukescoffeeco 📷 @dukes_coffee_co

23. CORK COFFEE ROASTERS

2 Bridge Street, Cork, Co. Cork, T23 PY7H.

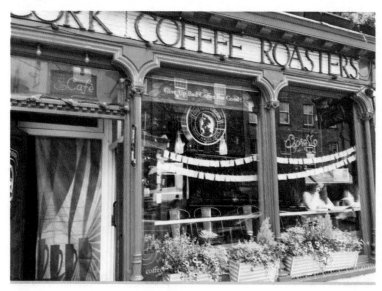

On any given morning, the crew at this eclectic and intimate cafe on Bridge Street serves students, doctors, lawyers and playwrights. All strands of the community congregate here to start the day with a Morning Growler – the refreshing house blend – and a tasty pastry or scone. And, due to the fact that customers are literally rubbing shoulders with each other, there's usually plenty of chatter too.

'That's the thing we like to foster,' says owner Anna Gowan. *'Whether it's meeting friends, sitting quietly, listening to good music, having a bit of banter with one of the baristas or just grabbing a takeaway, we strive to be a bright spot in people's day.'*

INSIDER'S TIP COMPLEMENT A FLAT WHITE WITH A BUTTERY ALMOND CROISSANT

Anna and her master roaster husband John used to sell their blends and beans, plus a menu of take-away coffees, at Kinsale Farmers' Market. As demand grew, they opened this cafe, followed by a second in French Church Street. And the pair continue to caffeinate the Cork community with their signature blend, Rebel City Espresso, and a crop of fresh-from-the-roastery beans.

KEY ROASTER
Cork Coffee Roasters

BREWING METHODS
Espresso, filter, drip

MACHINE
Black Eagle Nuova Simonelli

GRINDER
Mazzer

OPENING HOURS
Mon-Fri
7.30am-6.30pm
Sat 8am-6.30pm
Sun 9am-5pm

www.corkcoffee.com T 021 7319158

f Cork Coffee Roasters @corkcoffee @corkcoffeeroasters

24. WARREN ALLEN COFFEE – MAYLOR STREET

15 Maylor Street, Cork, Co Cork.

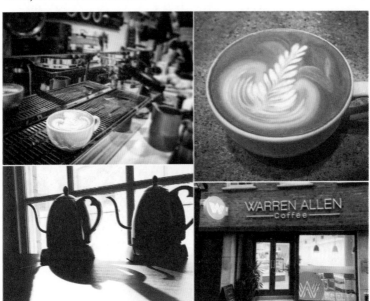

offee expert and barista trainer, Sean Kennedy sets a strict criteria for his coffee shops: only speciality coffee, made by baristas trained to competition standard make the grade.

And when combined with fresh, contemporary decor of whitewashed stone walls and retro light shades, a modern menu of wraps, salads, bagels and soups, and pastries that are freshly baked in-house each morning, it's a winning mix.

INSIDER'S TIP CHECK THE BOARD WHICH FEATURES A DIFFERENT NAME EACH DAY. IF IT'S YOUR NAME, YOU GET A FREE COFFEE

The Cork City outlet (there's a sister cafe in Bandon, too) focuses on espresso pulled through its La Marzocco machine, using Coffee Culture beans with Badger & Dodo, Square Mile and Cloud Picker as regular guest roasts.

Sean says, *'What sets us apart from other coffee shops is the champ-standard training that our baristas undertake so that they can create the perfect espresso every time.'*

KEY ROASTER
Coffee Culture
Roastery

BREWING METHOD
Espresso

MACHINE
La Marzocco

GRINDER
Nuova Simonelli

OPENING HOURS
Mon-Thu
7.30am-5pm
Fri-Sat
7.30am-6pm
Sun
10am-5pm

www.warrenallen.ie T: 021 4248282

f Warren Allen Coffee @warrenallencoffee @warrenallenco

№25. DUKES COFFEE COMPANY – CAREY'S LANE

4 Carey's Lane, Cork, Co. Cork.

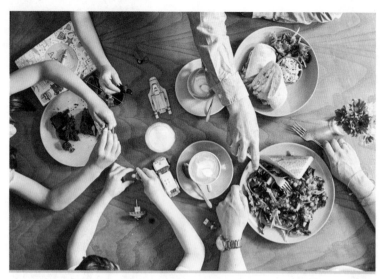

Expertly caffeinating the good folk of Cork since 2005, Dukes Coffee Company was doing the speciality thing before third wave went mainstream.

From day one, the team behind the family-run cafe has sought to share quality coffee with the masses, introducing Duke's eclectic mix of followers to the country's finest independent roasters.

INSIDER'S TIP OVER ITS TWO LOCATIONS, DUKES SERVES (GIVE OR TAKE) A WHOPPING 1,463 CUPS OF COFFEE EACH DAY

Hanging out in the heart of the Huguenot Quarter, Dukes fittingly occupies the former Newsome's coffee warehouse, and you'll still find its original enamel sign proudly adorning the wall. On the bar, local roasters Badger & Dodo, The Golden Bean and West Cork Coffee make regular appearances, though the offerings on the La Marzocco Linea often stretch to Dublin's 3fe and further afield.

With two floors and a clan of comfy sofas, we'd recommend cancelling your afternoon plans and kicking back with something special on Chemex before lazily lunching on stacked artisanal sandwiches through to afternoon doughy delights.

KEY ROASTER
Bewley's

BREWING METHODS
Espresso, V60, Chemex

MACHINE
La Marzocco
Linea Classic

GRINDER
Mahlkonig K30

OPENING HOURS
Mon-Sat 8am-5pm
Sun 10am-5pm

 Gluten FREE

 COFFEE BEANS AVAILABLE

 ALTERNATIVE MILK

 WIFI

 CYCLE FRIENDLY

 OUTDOOR SEATING

 DISABLED ACCESS

BRING YOUR OWN Cup.

www.dukes.ie T: 021 4905877

f DUKES Coffee Company 🐦 @dukescoffeeco @ @dukes_coffee_co

№26. THREE FOOLS COFFEE

The Glass Pod, Grand Parade, Cork, Co. Cork.

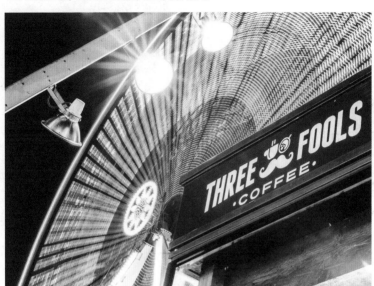

In some cafes, a triple grinder set-up, extensive brew bar and wall boasting the credentials of the latest own-roasted single origins signals speciality snobbery, but that couldn't be further from the truth at Cork's Three Fools Coffee.

The gang at the Grand Parade cafe has been nominated for a whole host of awards for their super friendly service, not to mention the cracking speciality coffee and gourmet grub.

INSIDER'S TIP THREE FOOLS' COLD BREW IS A BIG HITTER IN SUMMER – VISIT EARLY TO BAG A BOTTLE

When the sun's shining and the cold brew's flowing, you'll find up to five different coffees to sample at this gleaming glass pod.

And the care spent perfecting the brew is echoed in edible accomplices courtesy of local suppliers such as The Sandwich Stall and In.To.Food. We'd recommend getting stuck into the (nearly world famous) pork and black pudding sausage roll alongside your pick on V60.

KEY ROASTER
Three Fools Coffee

BREWING METHODS
Espresso, V60, Chemex, filter, cold brew

MACHINE
Royal Aviator

GRINDER
La Marzocco Vulcano

OPENING HOURS
Mon-Wed 8am-6pm
Thu-Fri 8am-7pm
Sat 9am-7pm
Sun 10am-6pm

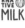

Gluten FREE

COFFEE BEANS AVAILABLE

ALTERNATIVE MILK

WIFI

OUTDOOR SEATING

DISABLED ACCESS

BRING YOUR OWN Cup.

www.threefoolscoffee.ie

f Three Fools Coffee 🐦 @3foolscoffee 📷 @threefoolscoffee

DUKES COFFEE COMPANY
№25

27. FILTER ESPRESSO AND BREW BAR

19 George's Quay, Cork, Co. Cork.

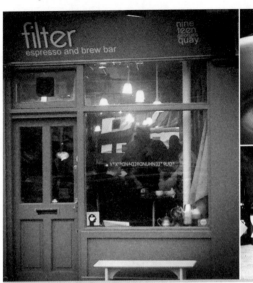

If you're tired of starting the day with the same old espresso fix and want to give your coffee drinking habits a shake up, you need a trip to Filter on George's Quay.

Drip, batch brew, a range of pourovers including V60, Kalita Wave and Chemex, along with the pseudo-scientific thrills of syphon, all bolster espresso for the exploratory caffeine fan.

And the choice doesn't end there, as with three espressos from each of the house roasters (Badger & Dodo, 3fe and The Golden Bean) and up to 20 single estate coffees for filter at any time, you'll be like a child in a sweetie shop, combining this coffee with that brew method.

INSIDER'S TIP CHECK OUT THE SISTER VENUE ON NORTH MAIN STREET WITH ITS CAFE AND EVENTS CENTRE

Mop up the inevitable caffeine shakes with homemade bakes and chill out to some sweet tunes – the baristas are a friendly bunch and will feed you well until you're ready for round two.

Keep the party going at home by picking up a bottle of the own-made cold press coffee to take away, along with something from the stash of home brew gear and bags of single estates.

KEY ROASTERS
Badger & Dodo, 3fe, The Golden Bean

BREWING METHODS
Espresso, Kalita Wave, drip, batch brew, V60, Chemex, syphon

MACHINE
Victoria Arduino Black Eagle VA388

GRINDERS
Mahlkonig Vari x 2, Nuova Simonelli Mythos One

OPENING HOURS
Mon-Fri
8am-6pm
Sat 9am-6pm
Sun 10am-5.30pm

Gluten FREE

COFFEE BEANS AVAILABLE

ALTERNATIVE MILK

WIFI

OUTDOOR seating

BRING YOUR OWN Cup.

T: 021 4550050

f FILTER 🐦 @filtercork 📷 @filter_espresso_and_brew_bar

№28. WARREN ALLEN COFFEE – BANDON

9-11 Pearse Street, Bandon, Co. Cork.

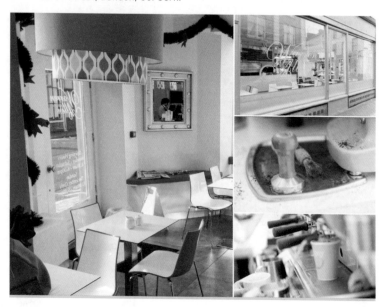

Born around the festive season of 2013, this fresh and zippy speciality coffee shop on the main street in Bandon has been a local fave since it opened.

And if you're wondering why, let owner Sean Kennedy explain: '*A friendly team with baristas who are trained to championship standard is what sets us apart from other coffee shops*'.

INSIDER'S TIP OWNER SEAN ALSO RUNS HIS OWN BARISTA TRAINING SCHOOL, SO YOU'RE IN SAFE HANDS

Grab a window seat and watch the world go by as you luxuriate in a well-pulled espresso, or take your laptop and catch up on emails; you'll find plug sockets and phone chargers at the counter seats.

The house roast comes courtesy of Coffee Culture, while guest beans from the likes of Square Mile and Badger & Dodo also feature.

Accompany your brew with freshly baked carbs from local Wildberry Bakery and a simple, tasty lunchtime menu of soups and sarnies, and you're set.

KEY ROASTER
Coffee Culture
Roastery

BREWING METHOD
Espresso

MACHINE
La Marzocco

GRINDER
Nuova Simonelli

OPENING HOURS
Mon-Thu
7.30am-5pm
Fri-Sat
7.30am-6pm
Sun 10am-5pm

Gluten FREE

COFFEE BEANS AVAILABLE

ALTERNATIVE MILK

WIFI

OUTDOOR Seating

DISABLED ACCESS

BRING YOUR OWN Cup

www.warrenallen.ie T: 023 8820767
f Warren Allen Coffee 🐦 @warrenallencoffee 📷 @warrenallenco

MAP 29. BEAN IN DINGLE

Green Street, Dingle, Co. Kerry.

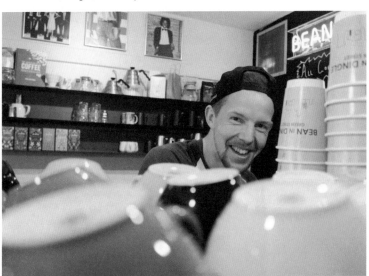

When barista brothers Justin and Luke Burgess set up Bean in Dingle in 2015 they roped in the whole family to make their first speciality shop a success.

Not only did mum and dad invest in the new venture, but you'll still find sister Georgia working shifts behind the bar in summer and Nana Anna's bakes creating carrot cake converts at the counter.

INSIDER'S TIP EVER TRIED A COLD BREW SLUSHY? NEITHER HAVE WE, BUT WE'RE INTRIGUED …

While Nana's cakes muster a steady flow of sweet-toothed disciples, it's the cracking cup of Badger & Dodo coffee that keeps the caffeine fans coming. The bespoke house blend – a killer combo of Brazil Ipanema, Guatemala San Juan and Ethiopia Yirgacheffe – makes for an intoxicating espresso, while the line-up of single origins on V60, Chemex and AeroPress offers something special for the filter buff.

A slick interior (splattered with Bean's signature canary yellow) and a pukka playlist (available to stream on Spotify) makes sticking around to sample the foodie offering (cinnamon rolls, creamy porridge and rustic sausage rolls) a no-brainer.

KEY ROASTER
Badger & Dodo

BREWING METHODS
AeroPress, V60,
Chemex, cold brew

MACHINE
Nuova Simonelli
Aurelia T3

GRINDERS
Mahlkonig Peak,
Anfim Milano

OPENING HOURS
Mon-Sat
8.30am-5.30pm

www.beanindingle.com T: 087 2992831

DUBLIN

FIRST DRAFT COFFEE
№ 37

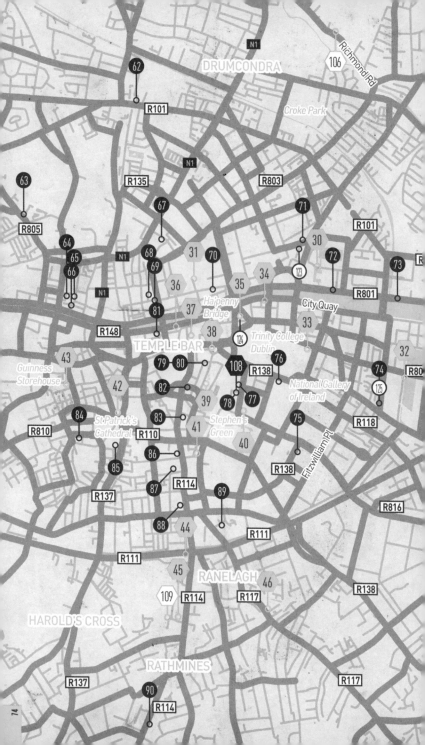

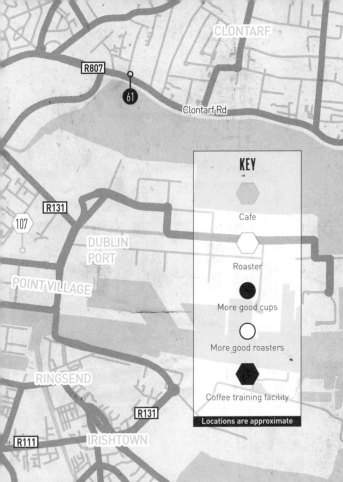

CLONTARF

R807

61

Clontarf Rd

R131

107

DUBLIN
PORT

POINT VILLAGE

RINGSEND

R131

R111

IRISHTOWN

KEY

Cafe

Roaster

More good cups

More good roasters

Coffee training facility

Locations are approximate

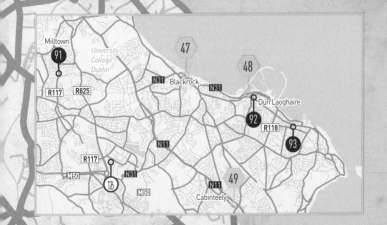

Milltown

91

University
College
Dublin

47

48

N31

Blackrock

N31

Dún Laoghaire

92

R118

93

N11

R117

R825

R117

M50

12

N31

M50

N11

49

Cabinteely

№30. BEAR MARKET COFFEE – GEORGE'S QUAY

Unit 2, Westblock, George's Quay, Dublin 1.

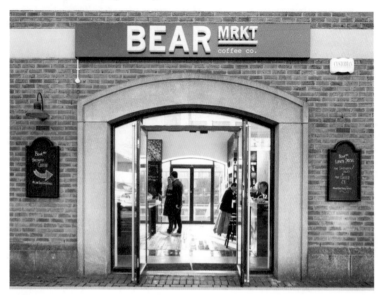

Welcomed into the family in December 2016, this George's Dock cafe is the big little brother to the original Bear Market Coffee.

What the original Blackrock shop lacks in space, the new venue makes up for with high ceilings, communal benches and huge windows flooding the room with light and providing views over the water.

INSIDER'S TIP CHECK OUT BEAR MARKET'S WEBSITE FOR HELPFUL HOME BREW GUIDES

The coffee geekery also gets kicked up a level here, with espresso options scribbled on the wall above the bar and every shot of the organic blend from Dublin roasters Silverskin weighed and dosed with obsessive precision. The quest for quality continues at the well-equipped brew bar, though for something really special we'd recommend a single estate cortado.

Lunch is a seasonal soup, salad and sandwich situation, with sugar support in the form of fluffy scones, killer cakes and indulgent chocolate brownies. Tea traitors can choose from a colourful loose leaf collection built into the sleek black counter.

KEY ROASTER
Silverskin Coffee Roasters

BREWING METHODS
Espresso, V60, AeroPress, Moccamaster

MACHINE
La Marzocco Strada 3 group

GRINDERS
Nuova Simonelli Mythos One x 2

OPENING HOURS
Mon-Fri 7am-4pm

www.bearmarket.ie T: 08 79582469

f Bear Market Coffee 🐦 @bearmarketco 📷 @bearmrktcoffee

31. JOE'S COFFEE – LIFFEY STREET

Liffey Street, Dublin 1.

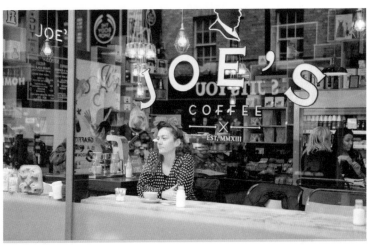

Domini and Peaches Kemp, the entrepreneurial sisters behind Joe's, had already made a name for themselves with a string of food establishments across Dublin before they joined with coffee enthusiast Roark Cassidy, to make their first foray into speciality in 2013.

Located in Ireland's oldest department store, the original Joe's has just one (huge) table, making the flagship outlet somewhere to chew the fat with fellow coffee enthusiasts.

INSIDER'S TIP
LOOK OUT FOR OCCASIONAL CUPPING AND COFFEE EVENTS

Two espressos and up to four filters make up the coffee offering, with key roasts from The Barn and guests from La Cabra, Tim Wendelboe, Square Mile and Koppi to sample.

Food is mostly of a grab-and-go nature with plenty of healthy options such as superfood salads and spirulina protein balls. Cold pressed juices come courtesy of sister company Alchemy.

In keeping with the vibe, a large retail section features all things coffee, and the band of cheery baristas are always happy to advise on home brew conundrums.

KEY ROASTER
The Barn

BREWING METHODS
Espresso,
Kalita Wave,
Chemex,
AeroPress,
batch brew

MACHINE
La Marzocco Linea
PB 3 group

GRINDERS
Nuova Simonelli
Mythos One,
Mahlkonig EK 43

OPENING HOURS
Mon-Wed
9.30am-7pm
Thu 9.30am-9pm
Fri 9.30am-8pm
Sat 9am-7pm
Sun 11am-7pm

Gluten FREE

COFFEE BEANS AVAILABLE

ALTERNATIVE MILK

WIFI

CYCLE FRIENDLY

OUTDOOR SEATING

FAMILY FRIENDLY

DISABLED ACCESS

BRING YOUR OWN Cup

COFFEE COURSES AVAILABLE

www.joes.ie T: 01 8748363

f Joe's Coffee, Dublin 🐦 @joesdublin 📷 @joesdublin

№32. THE ART OF COFFEE

Unit 1, Alto Vetro, Grand Canal Dock, Dublin 2.

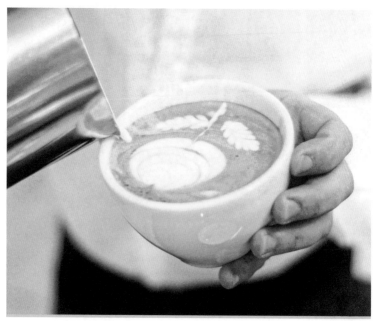

With a collection of latte art titles to his name, it's a sure bet that former Irish Barista Champ finalist, Ruslan Morcharskyy, didn't call his fleet of Dublin cafes The Art of Coffee just because it looks good in gold on a take-out cup.

INSIDER'S TIP LOOK OUT FOR THE NEW SHOP OPENING SOON IN DUBLIN CITY CENTRE

Every Bailies cortado, latte and flat white served at the flagship Grand Canal coffee shop is crafted with precision and signed with the barista's signature milky move. With exquisite rosettas, ferns and swans among the artwork adorning the crema, add a slice of the banana and pecan cake to the mix and you've got a serious Instagram situation going on.

If you're swinging by the dockside spot for a mobile brew, grab a sandwich – try the smoked salmon and cream cheese bagel or the mozzarella, tomato and pesto focaccia – to ease the munchies en route to your next hit.

KEY ROASTER
Bailies Coffee Roasters

BREWING METHOD
Espresso

MACHINE
La Marzocco

GRINDER
Nuova Simonelli Mythos One

OPENING HOURS
Mon-Sun
7am-5.30pm

COFFEE BEANS AVAILABLE

ALTERNATIVE MILK

WIFI

OUTDOOR seating

BRING YOUR OWN Cup.

www.theartofcoffee.ie T: 01 7645740

f The Art Of Coffee @ @theartofcoffeedublin

№33. SCIENCE GALLERY CAFE

Science Gallery, The Naughton Institute, TCD, Pearse Street, Dublin 2.

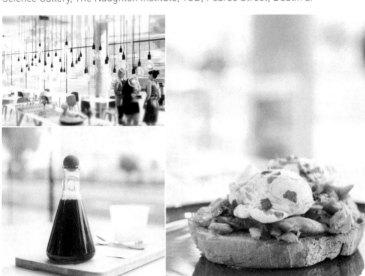

The city's Science Gallery probably isn't the first place you'd expect to discover speciality coffee in Dublin, but it's not just the exhibition pieces which get geeky at this cafe-come-cultural-hub.

Alongside experimental exhibitions and pondersome pop-ups, locally roasted Cloud Picker beans are explored via V60, AeroPress and batch at the brew bar set-up, as well as being extracted to precise perfection on the cafe's tech-tastic Sanremo Opera machine.

There are usually at least two espressos and one filter to sample, with more beans from the micro roaster available for further investigation at home.

INSIDER'S TIP GET THE SALAD AND QUESTION HOW SOMETHING SO HEALTHY CAN TASTE SO GOOD

Located in the belly of a previously abandoned car park, a bright white communal bench lies at the heart of this light and airy coffee shop, with smaller tables lining the floor-to-ceiling glass frontage.

Morning and afternoon, there's plenty of room in which to savour a brew with the clan of keyboard commuters, but bagging a table for the vibrant seasonal lunch menu requires rigorous methodology.

KEY ROASTER
Cloud Picker

BREWING METHODS
Espresso,
AeroPress, V60,
batch brew,
Bonavita 8 Cup

MACHINE
Sanremo Opera
3 group

GRINDERS
Mahlkonig K30,
Mahlkonig EK 43,
Nuova Simonelli
Mythos One

OPENING HOURS
Mon 8am-5pm
Tue-Fri 8am-8pm
Sat-Sun 12pm-6pm

www.dublin.sciencegallery.com/cafe T: 01 8964138

f Science Gallery Café 🐦 @scigallerycafe 📷 @scigallerycafe

№34. SHOE LANE

7 Tara Street, Dublin 2.

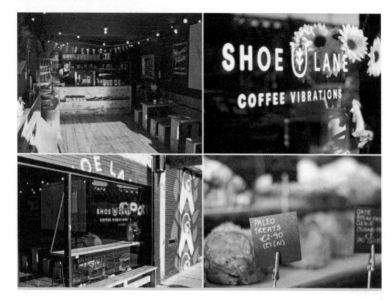

Turn back the clock 150 years and the vintage Singer machines and traditional shoe making materials in the window of this busy little coffee shop on Tara Street (formerly known as Shoe Lane) would have been making shoes on the same spot.

In 2017, instead of fashioning footwear, owners Jonathan and Jane are crafting speciality coffee for the fleet of commuters and caffeine lovers that flock to the cafe.

INSIDER'S TIP: STICK AROUND POST RUSH HOUR AND ENJOY THE ECLECTIC TUNES WITH A FULL CIRCLE FILTER

Smack bang in the centre of Dublin, Shoe Lane's location means that pre 9am the place is packed out, though a simplified menu of black/white, long/short, filters out a lot of the fuss. While the baked haul on the counter – dusted almond croissants and gooey chocolate orange brownies – makes the perfect partner to your pick of the espressos from local roaster, Full Circle.

Dairy dodgers will discover a hefty selection of milk alternatives, including wild card options such as coconut and hemp, plus vegan cakes and paleo treats, while home brewers can stock up on the latest coffee kit.

KEY ROASTER
Full Circle Coffee

BREWING METHODS
Espresso,
batch filter

MACHINES
La Marzocco FB/70,
Marco Bru F45A

GRINDERS
Nuova Simonelli
Mythos Clima Pro,
Mahlkonig EK 43

OPENING HOURS
Mon-Fri
6.30am-6.30pm
Sat 10am-4pm

 Gluten FREE
 COFFEE BEANS AVAILABLE
 ALTERNATIVE MILK
 WIFI
 CYCLE FRIENDLY
 OUTDOOR SEATING
 BRING YOUR OWN CUP

www.shoelanecoffee.ie T: 01 6779471

f Shoe Lane Coffee @shoelanecoffee @shoelanecoffee

№35. 9TH DEGREE COFFEE ROASTERS

28 Westmorland Street, Dublin 2.

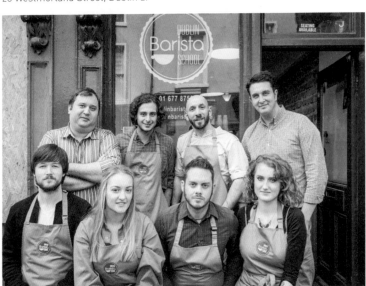

After five years of crafting top grade coffee and training a league of the city's slickest espresso slingers at Dublin Barista School, James McCormack added roasting to his caffeine cache in 2016 when he opened his second venue and micro roastery.

With Q Grader Alin Giriada baking the beans at first 9th Degree HQ, and Irish Latte Art Champion Renata Khedun overseeing the sleek La Cimbali machine at the Westmorland Street cafe, it's a sure bet that your morning brew will hit the mark.

'We only supply our own coffee shops so that we can keep the quality consistently high,' explains James. *'Our coffee is roasted one week in advance so it has time to rest, which ensures the coffee has reached its full flavour potential.'*

INSIDER'S TIP SWITCH UP YOUR USUAL HALF OF GUINNESS FOR 9TH DEGREE'S 24 HOUR NITRO

An arsenal of brewing kit means the latest single origin – which changes daily FYI – can be sampled on batch brew, Chemex, AeroPress or V60. Though plumping for a flattie – and a slice of something sweet from the counter – is worth it to witness Renata's milky skills.

KEY ROASTER
9th Degree Coffee Roasters

BREWING METHODS
Espresso, V60, Chemex, AeroPress, batch brew, cold brew, nitro

MACHINE
Nuova Simonelli Aurelia II T3

GRINDERS
Nuova Simonelli Mythos One, Mahlkonig EK 43

OPENING HOURS
Mon-Fri
7.30am-5pm

Gluten FREE

COFFEE BEANS AVAILABLE

ALTERNATIVE MILK

WIFI

OUTDOOR seating

BRING YOUR OWN Cup.

COFFEE COURSES AVAILABLE

www.9thdegree.ie T: 01 6778756

f 9th Degree Coffee Roasters 🐦 @9thdegreecoffee 📷 @9thdegreecoffee

36. CAFE AT INDIGO & CLOTH

9 Essex Street East, Temple Bar, Dublin 2.

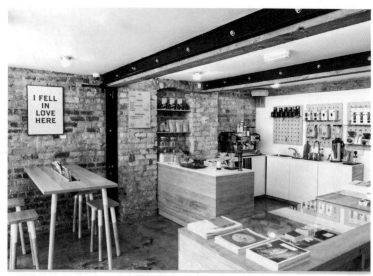

In a match made by the Instagram gods, this coffee shop, training lab and event space below Indigo & Cloth is an aspirational mash-up from Dublin's slickest design studio and the brew buffs at Clement & Pekoe.

INSIDER'S TIP THIS IS YOUR GO-TO FOR A FINELY CRAFTED COFFEE TO-GO IN THE CITY CENTRE

Tucked into one of the city's quieter cobbled streets, it's a great spot in which to steal away from boisterous Temple Bar and indulge in an expertly poured Climpson & Sons espresso, while flicking through a stack of design mags.

Making the most of the exposed brick walls and a couple of strategically placed, pared-back pieces, this pocket-sized shop is deceptively spacious, housing just a cluster of stools. If you do score a seat in the window or around the communal bench, make sure to explore the filter options and line-up of guest roasts from Irish indies at the bar.

Caffeine levels topped up, stock up on Clement & Pekoe loose leaf tea, Climpson & Sons coffee and Dublin-made honey and soap, before venturing upstairs to browse the curious curation of menswear at Indigo & Cloth's studio.

KEY ROASTER
Climpson & Sons

BREWING METHODS
Espresso, V60, AeroPress, woodneck

MACHINE
La Marzocco

GRINDERS
Nuova Simonelli Mythos, Mahlkonig Tanzania

OPENING HOURS
Mon-Sat
10am-6pm
Sun 12pm-5pm

www.clementandpekoe.com

f Clement & Pekoe 🐦 @clementandpekoe 📷 @clementandpekoe

№37. FIRST DRAFT COFFEE

1st Floor, Filmbase, Curved Street, Temple Bar, Dublin 2.

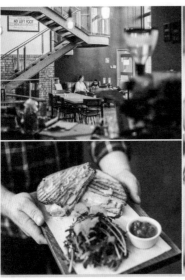

If you're after a knockout cup of coffee in the city, there are few better places to seek caffeinated refuge than a barista training specialist that serves silky flat whites and phenomenal filters on the side.

Moving First Draft HQ to Dublin's Filmbase in 2016 to add a speciality shop to the set-up, owner (and SCA education coordinator for Ireland) Ger O'Donohoe sought to create a space where he and his team of professional espresso slingers could capitalise on their 20 years of experience, with an inclusive cafe.

INSIDER'S TIP BRUSH UP ON YOUR CUPPING CREDENTIALS WITH AN INTRODUCTION TO CUPPING CLASS

As the Irish distributor for Berlin's The Barn, visitors to the spacious first floor coffee shop can sample the latest import on espresso or pourover, with high-quality tasting notes available on request. If you're after something specialist of the loose-leaf variety, you'll also find a good selection of teas from Camellia Sinensis of Montreal. In addition to a busy calendar of SCA-accredited classes – ranging from introductory to advanced brewing and barista skills – the sociable space holds regular events, music evenings and workshops.

KEY ROASTER
The Barn

BREWING METHODS
Espresso, pourover

MACHINE
La Marzocco Linea

GRINDERS
Nuova Simonelli Mythos One, Mahlkonig EK 43

OPENING HOURS
Mon-Sat
10am-5pm

www.firstdraftcoffee.com T: 086 8604517

f First Draft Coffee 🐦 @1stdraftcoffee 📷 @firstdraftcoffee

№38. COFFEEANGEL HQ

3 Trinity Street, Dublin, D02 H684.

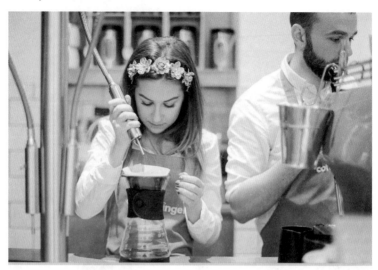

It's plain to see why Caroline Sleiman-Purdy and husband Karl Purdy fell for this impressive red brick, four-storey, listed building on Dublin's Trinity Street.

Gorgeous old features such as open fireplaces, a mahogany staircase and original stained glass windows artfully blend with contemporary coffee shop cool to create a unique HQ for Coffeeangel's six outlets in the city.

INSIDER'S TIP: THE REUBEN BAGUETTE IS THE LOCALS' CHOICE

Hungry hedonists flock here to seek out quinoa slices, brownies, quiche, soup and berry scones, rustled up daily in Coffeeangel's own kitchen. While parched pleasure-mongers linger over exclusive single origins and house blends roasted in Belfast.

'It's not only about the coffee,' smiles Caroline. 'Great coffee is just our standard. At HQ, as at all of our shops, it's our welcoming, enthusiastic baristas and architecturally designed space that combine to create an environment our customers want to be in.'

HQ is the newest addition to the friendly and welcoming Coffeeangel portfolio and offers private rooms for hire, as well as a training lab. You can also pick up a bag of beans to take home from any of the locations.

KEY ROASTER
Bailies Coffee Roasters

BREWING METHODS
Espresso, pourover

MACHINE
La Marzocco Linea PB

GRINDERS
Mythos One, Mahlkonig EK 43

OPENING HOURS
Mon-Fri
7.30am-5pm
Sat 9am-5pm

www.coffeeangel.com T: 01 9060003

f coffeeangel @coffeeangel @coffeeangel

№39. CLEMENT & PEKOE

50 South William Street, Dublin 2.

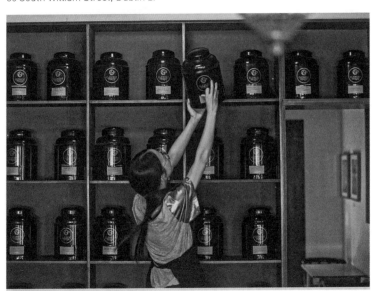

A token speciality tea on the menu at a third wave coffee shop is pretty standard but few share a dedication to the brew brothers like Clement & Pekoe.

Meeting the exacting requirements of coffee aficionados as thoroughly as those of tea enthusiasts, the cafe on South William Street started out as a standing-only espresso bar and tea shop in 2011. In the following years, the shop has blossomed into a loose leaf emporium and roomy meeting space, fuelling all types of caffeine lovers from its finely stocked bar.

INSIDER'S TIP EVER TRIED KOMBUCHA CASCARA? GIVE IT A WHIRL AT THE SOUTH WILLIAM STREET STORE

While the walls are lined with caddies harbouring Clement & Pekoe's award winning teas, the grinders are stocked with indie roasters' beany bounties. London's Climpson & Sons provides the house espresso, while Irish roasters Baobab and Upside make regular appearances as both espresso and V60.

Stock up on your home haul from the brimming retail shelves, where you'll also find brewing gear such as AeroPress and Chemex.

KEY ROASTER
Climpson & Sons

BREWING METHODS
Espresso, V60, filter

MACHINE
La Marzocco
Linea PB

GRINDERS
Anfim Caimano,
Mahlkonig
Tanzania,
Mahlkonig
Guatemala,
Nuova Simonelli
Mythos One

OPENING HOURS
Mon-Fri 8am-7pm
Sat 9am-6.30pm
Sun 11am-6pm

www.clementandpekoe.com

№40. TANG

23c Dawson Street, Dublin 2.

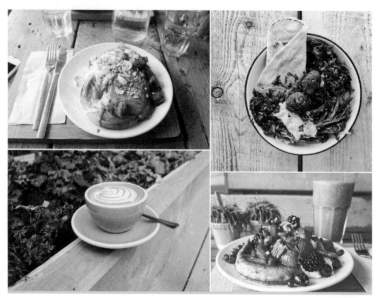

The new savoury sibling from the guys at Yogism in George's Arcade, this is your au courant can't-miss for speciality coffee accompanied by a thoroughly delicious (and healthy) menu of paleo pick-me-ups and Mediterranean munches.

Coffee is kept simple with two options (black and white) served with organic or homemade almond milk, and made with beans from Upside Coffee (with London's Assembly Coffee in the hopper occasionally). Local 3fe does the honours on filter which is served as Chemex, Kalita Wave and AeroPress.

INSIDER'S TIP ONE TOO MANY ESPRESSOS? SOOTHE THE SHAKES WITH A SUPERFOOD SMOOTHIE

Breakfast is such a cracking affair here that you need to pencil this in for the morning slot of your Dublin coffee tour. Let the menu do the talking: buckwheat flour pancakes with real greek yogurt, fresh berries, cacao nibs, pecan nuts, honey and almond butter? Don't mind if we do. Or lunch of turkish baked eggs with greek yogurt, paprika and spiced mixed peppers and tomatoes? We thought so ...

KEY ROASTER
Upside Coffee

BREWING METHODS
Espresso,
AeroPress,
Chemex,
Kalita Wave

MACHINE
Nuova Simonelli
Aurelia II

GRINDER
Nuova Simonelli
Mythos One

OPENING HOURS
Mon-Fri
7.30am-5pm
Sat
10am-5pm
Sun
11am-3.30pm

www.yogism.ie/tang/ T: 086 3915401

f TANG Food 🐦 @tangfood 📷 @tangfood

No. 41. JOE'S COFFEE – MONTAGUE STREET

15 Montague Street, Dublin 2.

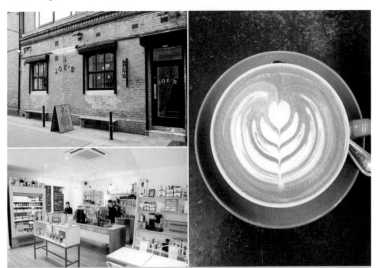

The second instalment in the Joe's trilogy can be found on Montague Street, a short stroll from Stephen's Green.

Traditionally known for its rambunctious nightlife, this part of Dublin in recent years has gained a reputation for good food and speciality coffee – and Joe's can be thanked for the latter.

Berlin's The Barn is the star of the coffee show at this stylish shop, with supporting roles from some of Europe's most acclaimed roasters. There are typically two espressos and a filter or two on offer – ask one of the friendly team for the latest tasting notes and recommendations.

A winning mix of healthy-eating options and lip smacking coffee keep the caffeine fans coming back for more at Joe's. And don't be fooled by the small exterior; you'll find plenty of space in which to explore the eating options in the roomy area upstairs.

INSIDER'S TIP THE JUICES ARE SUPPLIED BY SISTER COMPANY ALCHEMY

The crew hosts regular cuppings and coffee-themed events and offers SCA training for those wishing to take their coffee knowledge to the next level.

KEY ROASTER
The Barn

BREWING METHODS
Espresso,
AeroPress,
batch brew

MACHINE
La Marzocco Linea
PB ABR

GRINDERS
Nuova Simonelli
Mythos One,
Mahlkonig EK 43

OPENING HOURS
Mon–Fri 8am-5pm
Sat 9am-4pm
Sun 10am-4pm

www.joes.ie T: 01 4758630

f Joe's Coffee, Dublin 🐦 @joesdublin 📷 @joesdublin

№42. TWO PUPS COFFEE
74 Francis Street, Dublin 8.

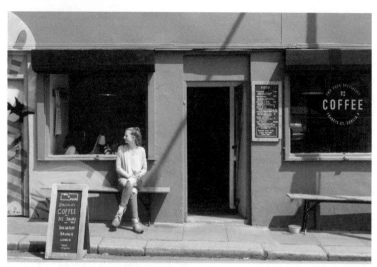

In Dublin slang, a pup is something of a chancer or a rogue. And in the case of this popular Liberties cafe, the pups are owner Kevin Douglas and partner Zoe Ewing Evans.

The two started selling coffee at festivals and markets before occupying a tiny corner of a vintage clothing shop on Francis Street. The popularity of the duo's coffee offering and the super friendly service allowed them to slowly expand and take over the whole space while adding a full menu to the mix.

The kitchen focuses on healthy, comforting fodder such as rich lentil dahl and avo on toast with garlic peanut butter. And whether you're stopping by for breakfast or lazy lunching with friends, the use of mostly organic, vegetarian and locally sourced ingredients means eating out is easy on the conscience.

INSIDER'S TIP THE CAFE HAS GIVEN A NEW HOME TO CHAIRS FROM UNIVERSITY COLLEGE DUBLIN'S EXAM HALLS

The crew uses Square Mile's Red Brick – a perfectly balanced blend of Brazilian, Colombian and Ethiopian beans – for its milk-based coffees, while guest roasts from 3fe, Square Mile and April rotate on filter. There's also a full range of retail bags which can be ground to order.

KEY ROASTERS
Square Mile, 3fe

BREWING METHODS
Espresso,
batch brew

MACHINE
Nuova Simonelli
Aurelia T3

GRINDERS
Nuova Simonelli
Mythos,
Mahlkonig EK 43

OPENING HOURS
Mon-Fri
8am-5pm
Sat
9.30am-5pm

Gluten FREE

COFFEE BEANS AVAILABLE

ALTERNATIVE MILK

WIFI

CYCLE FRIENDLY

OUTDOOR SEATING

FAMILY FRIENDLY

T: 087 3526655

f Two Pups Coffee 🐦 @twopupscoffee1 @ @two_pups_coffee

43. LEGIT COFFEE CO

1 Meath Mart, Meath Street, Dublin 8.

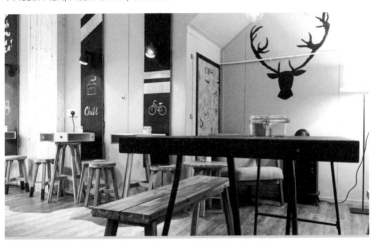

Meath Street and the surrounding area had a severe shortage of decent coffee until LEGIT exploded onto the scene. And since opening, the cool little cafe has been a huge hit with both locals and tourists visiting the nearby Guinness Storehouse.

The house roast is supplied by local roaster Baobab, though not-so-local options from Berlin's Bonanza and Coffee Proficiency in Poland also make regular guest appearances in the grinder. Head barista Martin is always on hand to answer any coffee curiosities and from time to time he leads evening cupping sessions at the cafe.

INSIDER'S TIP LOOK CLOSELY AND YOU'LL SPOT CLUES THAT THIS IS AN OLD BUTCHER SHOP

The array of beguiling pastries adorning the counter, such as Brazilian quindim (coconut custard) or French canelé with dulce de leche and chocolate, hint at owners Damien and Jamaycon's South American and European heritages. There's a brunch menu too if you want to soak up the homely atmosphere, otherwise the popular sausage rolls and quality sandwiches are excellent grab-and-go options.

As well as the best coffee in the neighbourhood, LEGIT also offers matcha latte, fresh juice and gourmet tea from Wall & Keogh.

KEY ROASTER
Baobab Coffee Roasters

BREWING METHODS
Chemex, V60, AeroPress, filter drip

MACHINE
Victoria Arduino Black Eagle

GRINDERS
Mahlkonig EK 43, Compak E8, Victoria Arduino Mythos

OPENING HOURS
Mon-Fri 7.30am-5pm
Sat 9.30am-5pm

www.legitcoffeeco.com

 LEGIT COFFEE CO @legitcoffeeco @legitcoffeeco

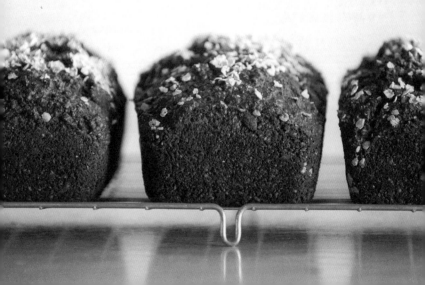

44. GROVE ROAD

1 Rathmines Road Lower, Rathmines, Dublin 6.

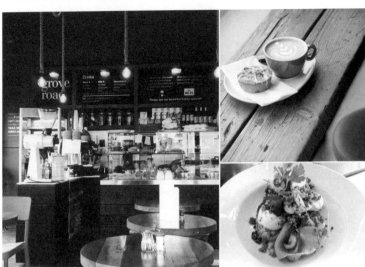

Speciality addicts may be spoilt for choice in the Dublin 6 neighbourhood these days, but ever since Grove Road popped up as one of the original trailblazers, it's held its position as a leading light.

On the corner of Rathmines Bridge and the Grand Canal, this little cafe has been the savvy coffee drinker's choice for a consistently great cup since 2014.

Taking beans which have been artfully fired to perfection in County Wicklow by Roasted Brown, the friendly barista team coaxes them into delicious espresso and AeroPress brews for Grove Road's loyal customers.

With the added benefits of sweeping panoramic views of the canal, healthy juices and an enticing all-day brekkie and brunch menu, it's easy to see how this happening hub lives up to its motto of *'Do simple things well, make things tasty and be nice to people.'*

INSIDER'S TIP TRY A SMASH: DOLLOPS OF CREAMY AVO, FETA AND POACHED EGG ON GRIDDLED SOURDOUGH

Locals and visitors can rejoice in the fact that even on busy weekends when seats are scarce, everything is available as take-away, while the canal is a stone's throw away for feasting alfresco.

KEY ROASTER
Roasted Brown

BREWING METHODS
Espresso,
AeroPress

MACHINE
Nuova Simonelli
Aurelia

GRINDERS
Anfim,
Mahlkonig EK 43

OPENING HOURS
Mon-Fri
7.30am-5pm
Sat 9am-5pm
Sun 10am-5pm

www.groveroadcafe.ie T: 01 5446639

f Grove Road 🐦 @groveroadcafe @ @groverroad

№45. TWO FIFTY SQUARE COFFEE BAR

10 Williams Park, Rathmines Road Lower, Rathmines, Dublin 6.

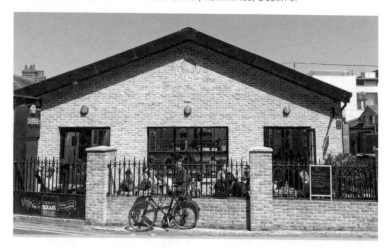

Tucked down a quiet lane, away from the busy main thoroughfare of Rathmines, on first impression it would be easy to assume Two Fifty Square is a hidden gem. But that's definitely not the case, as this bustling cafe is well-loved by Dubliners for cranking out some of the best brunches and speciality coffee in town.

Getting into coffee in a serious way while in Australia, owner Adam McMenamin was keen to recreate the buzz around quality coffee on his return to Ireland. First came the roastery, which now supplies cafes and restaurants across Dublin, then followed the speciality shop of the same name.

INSIDER'S TIP TRY SISTER CAFE, ALPHA ESPRESSO, AT THE NEARBY SWAN LEISURE CENTRE

Occupying a former bakery, the Two Fifty Square cafe is airy and spacious with a mural of Melbourne's skyline overhead in homage to the city's excellent cafe culture. Outdoors, two areas provide spots for soaking up the rays with an iced brew in hand.

On the coffee front, choose between espresso, filter or cold and get the low-down on each from the simple tasting notes. All-day brunch dishes such as spanish baked eggs with chorizo, and brekkie tortillas make for tempting foodie offerings, with creative sandwich options come lunchtime.

KEY ROASTER
Two Fifty Square

BREWING METHODS
Espresso, V60, AeroPress

MACHINE
Sanremo Opera 3 group

GRINDERS
Sanremo SR83 x 3, Mahlkonig EK 43

OPENING HOURS
Mon-Fri
8am-6pm
Sat-Sun
9am-6pm

www.twofiftysquare.ie T: 01 4968336

f Two Fifty Square Coffee Roasters 🐦 @250squarecoffee 📷 @250squarecoffee

NO.46. NICK'S COFFEE CO

20 High Street, Ranelagh, Dublin 6.

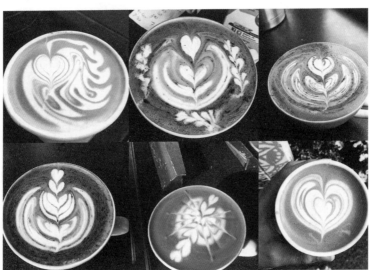

One of the first places in the city to start serving speciality, Nick's has become something of a Dublin institution. It may be small in scale, but long opening hours and a legion of followers means this much-loved cafe pumps out vast amounts of coffee day after day.

Owner Nick Seymour caught the brew bug in Australia (wait, we've heard this before) and soon progressed to learning the art of roasting and blending. His signature blend was crafted with a little help from Belfast coffee legend Russell Bailie, and features four different organic beans from Brazil, Ethiopia, Guatemala and India.

INSIDER'S TIP NICK'S HAS A SPIN-OFF CAFE IN WICKLOW TOWN CALLED DAVE'S COFFEE

Most of the trade is takeaway, though there's a small amount of seating among the quirky artwork and wall murals, plus cakes from a local bakery to tempt caffeine fiends to stay a little longer.

As an integral part of the local community in Ranelagh, Nick offers free coffee for over 65s, as well as doing his bit for local sports teams and other groups.

KEY ROASTER
Bailies Coffee Roasters

BREWING METHODS
Espresso, filter, AeroPress

MACHINE
La Marzocco Linea PB 3 group

GRINDERS
Mythos, Mazzer

OPENING HOURS
Mon-Sun
7am-9pm

T: 086 3838203

f Nicks Coffee Company Ltd. 🐦 @nickscoffeeco 📷 @nickscoffeecompany

№47. BEAR MARKET COFFEE – BLACKROCK

19 Main Street, Blackrock, Dublin.

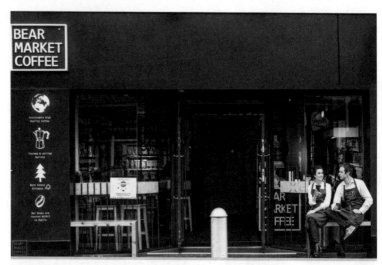

The original speciality shop from Stephen and Ruth Deasy, Black Rock's Bear Market Coffee is the happy consequence of two abandoned careers in architecture.

The dinky cafe's rugged interior – all reinforced steel, recycled timber and exposed ceilings – may hint at a background in design but these days you're more likely to find the couple navigating the Astoria 3 group machine than building plans.

Big on positive vibes, Stephen, Ruth and the gaggle of brushed-up baristas shun snobbery to create an inclusive coffee culture. Don't be afraid to quiz the crew on the latest blend from local roasters Silverskin when you swing by for your morning flattie, or book yourself on a coffee course for the filter full monty.

INSIDER'S TIP GET COSY WITH A 6OZ CUB AND SLICE OF CARROT CAKE FROM THE COUNTER

Stuffed sarnies, freshly baked pastries and homemade cakes keep the coffee company on the counter, with beans to brew at home and the latest filter kit filling the contemporary wall racking.

A new extension means there are also a few spots for sunning in the garden when the weather's good.

KEY ROASTER
Silverskin Coffee Roasters

BREWING METHODS
Espresso, V60, AeroPress

MACHINE
Astoria Plus 4 You 3 group

GRINDERS
Nuova Simonelli Mythos One Clima x 2

OPENING HOURS
Mon-Fri 7am-5pm
Sat 8am-6pm
Sun 9am-5pm

www.bearmarket.ie T: 087 9582469

f Bear Market Coffee 🐦 @bearmarketco 📷 @bearmrktcoffee

MAP № 48. THE GIDDY GOOSE CAFE

138/139 George's Street Lower, Dún Laoghaire, Dublin.

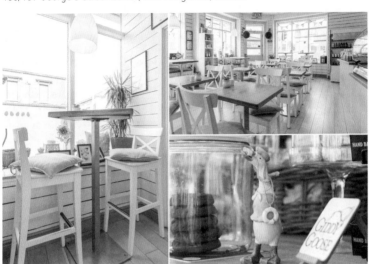

With its panelled walls and palette of white and soft blues, you'd be forgiven for thinking you'd stumbled upon a beachside bungalow in New England. And though it doesn't boast bayside views, The Giddy Goose Cafe certainly harbours some of the best coffee going in Dún Laoghaire.

Husband and wife team, Brian and Roxana Hefferon have been running this welcoming corner cafe since 2009, switching up the coffee offering to speciality standards in 2014. Badger & Dodo's famous Blackwater Blend was enlisted to do the job, and can still be found rocking the espresso based brews. Single origin coffees often make guests appearances too – ask to sample the current beans on V60, syphon or AeroPress.

INSIDER'S TIP PUSHING THE BOUNDARIES OF YOUR CAFFEINE CAPABILITY? TRY THE SWISS WATER DECAF

When she's not pumping out quality coffee and fabulous fodder to the league of office workers, families and day-trippers, Roxana is busy studying for her SCA diploma in speciality coffee.

A visit to this charming spot wouldn't be complete without sampling one of its four reincarnations of the full Irish: the Big, the Little, the Good and the Veggie Goose.

KEY ROASTER
Badger & Dodo

BREWING METHODS
Espresso, V60,
AeroPress, syphon

MACHINE
Astoria Plus 4 You

GRINDER
Anfim Super Caimano

OPENING HOURS
Mon-Fri
8am-5pm
Sat 10am-5pm

www.giddygoosecafe.ie T: 01 2148634

f The Giddy Goose Cafe 🐦 @giddygoose 📷 @thegiddygoose

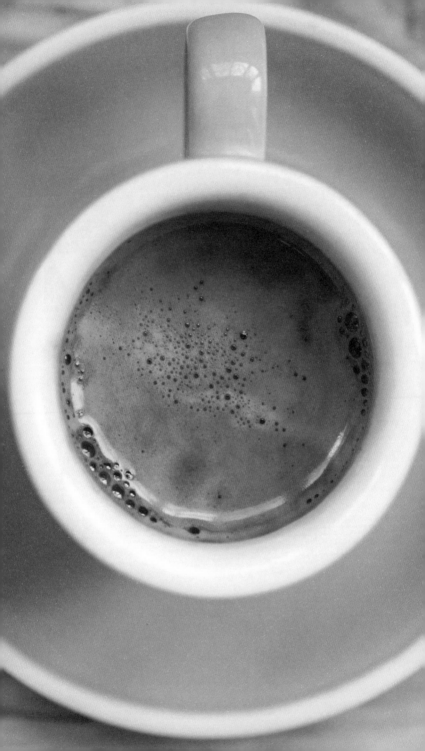

49. URBUN CAFE

Old Bray Road, Cabinteely, Dublin 18.

A mission to serve amazing food and awesome coffee under one industrial roof is what led to the birth of Urbun Cafe in the swish suburbs of Cabinteely.

Owner Katie Gilroy and her young team are resolute about using local produce in dishes such as the Urbun Club: free range roast chicken, smoked bacon and soft-fried North Wicklow eggs on baked-down-the-road bread. The berry scones are to die for, too.

'You'd get up in the middle of the night for one of our freshly baked berry scones dripping with homemade jam,' smiles Katie.

INSIDER'S TIP — EATING CLEAN? TRY THE VEGAN, SUGAR-FREE OAT AND NUT BARS

Yet that's only half the story. Urbun started out selling cakes at a local farmers' market where Katie stumbled upon the smoothest, sweetest coffee she'd ever tasted. Thus began a beautiful relationship with Cork's Badger & Dodo. Six years later and the roaster's beans still feature in the Blackwater house blend and as a weekly-changing single origin.

'It's all under one roof in the heart of Dublin 18: exceptional coffee, delicious food, take-home brewing paraphernalia and an awesome team of bun-loving, friendly individuals,' says Katie. *'And we've even got Cabinteely Park as our neighbour.'*

KEY ROASTER
Badger & Dodo

BREWING METHODS
Espresso,
batch brew

MACHINE
La Marzocco Linea

GRINDER
Mahlkonig

OPENING HOURS
Mon-Fri
8am-5pm
Sat-Sun
10am-5pm

www.urbun.ie T 01 2848872

f Urbun 🐦 @urbuncafe 📷 @urbuncafe

MORE GOOD CUPS

So many exceptional places to drink coffee ...

MAP 50
URSA MINOR
45 Ann Street, Ballycastle, BT54 6AA.
www.ursaminorbakehouse.com

MAP 51
LOST & FOUND
2 Queen Street, Coleraine,
Co. Londonderry, BT52 1BE.
www.wearelostandfound.com

MAP 52
BULLITT HOTEL
40a Church Lane, Belfast, BT1 4QN.
www.bullitthotel.com

MAP 53
TOWN SQUARE
45 Botanic Avenue, Belfast, BT7 1HZ.
www.townsquarebelfast.com

MAP 54
KAFFE O - BOTANIC
73 Botanic Avenue, Belfast, BT7 1JL.
www.kaffeo.coffee

MAP 55
INDIGO COFFEE & GELATO
86 Stranmillis Road, Belfast, BT9 5AD.

MAP 56
KAFFE O - ORMEAU
411 Ormeau Road, Belfast, BT7 3GP.
www.kaffeo.coffee

MAP 57
ROOT & BRANCH BREW BAR
1b Jameson Street, Belfast, BT7 2GU.
www.rootandbranch.coffee

MAP 58
GROUNDED
10 Merchants Quay, Newry, Co. Down,
BT35 6AH.

MAP 59
THE COUNTER
Canal Road, Letterkenny, Co. Donegal.
www.thecounterdeli.com

MAP №60
JAVA REPUBLIC
510 Mitchelstown Road, Northwest Business Park, Ballycoolin, Dublin 15, D15 PY8H

www.javarepublic.com

MAP №61
EBB & FLOW COFFEE
56 Clontarf Road, Dublin 3.

www.ebbandflow.ie

MAP №62
TWO BOYS BREW
375 North Circular Road, Phibsborough, Dublin 7.

www.twoboysbrew.ie

MAP №63
LOVE SUPREME COFFEE
57 Manor Street, Stoneybatter, Dublin 7.

www.lovesupreme.ie

MAP №64
PROPER ORDER COFFEE CO.
7 Haymarket, Smithfield, Dublin 7.

www.properordercoffeeco.com

MAP №65
PROVENDER & FAMILY – SMITHFIELD SQUARE
57 Smithfield Square, Dublin 7.

MAP №66
URBANITY COFFEE
The Glass House, 11 Coke Lane, Smithfield, Dublin 7.

www.urbanitycoffee.ie

MAP №67
BLAS CAFE
26 Kings Inns Street, Dublin 1.

www.blascafe.ie

MAP №68
OXMANTOWN
16 Mary's Abbey, City Markets, Dublin 7.

www.oxmantown.com

MAP №69
BROTHER HUBBARD NORTH
153 Capel Street, Dublin 1.

www.brotherhubbard.ie

MAP 70
VICE COFFEE INC.
Inside Wigwam, 54 Abbey Street Middle, Dublin 1.

www.vicecoffeeinc.com

MAP 71
LAINE, MY LOVE
3 Joyces Walk, Talbot Street, Dublin 1.

www.lainemylove.com

MAP 72
COFFEEANGEL CHQ
Sean O'Casey Bridge, Custom House Quay, Dublin, D01 KF84.

www.coffeeangel.com

MAP 73
COFFEEANGEL NWQ
Spencer Dock, North Wall Quay, Dublin 1.

www.coffeeangel.com

MAP 74
3FE
32 Grand Canal Street Lower, Dublin 2.

www.3fe.com

MAP 75
COFFEEANGEL PSL
27 Pembroke Street Lower, Dublin, D02 T922.

www.coffeeangel.com

MAP 76
COFFEEANGEL TCD
15 Leinster Street South, Dublin, D02 CY95.

www.coffeeangel.com

MAP 77
COFFEEANGEL SAS
16 Anne Street South, Dublin, D02 VF29.

www.coffeeangel.com

MAP 78
DUBLIN BARISTA SCHOOL CAFE
19a Anne Street South, Dublin 2.

www.dublinbaristaschool.ie

MAP 79
INDUSTRY & CO
41 a/b Drury Street, Dublin 2.

www.industryandco.com

MAP 80
KAPH
31 Drury Street, Dublin 2.

www.kaph.ie

81
TAMP AND STITCH
Unit 3, Scarlet Row, Essex Street West,
Temple Bar, Dublin 8.

www.tampandstitch.com

82
GRANTHAMS
8 Aungier Street, Dublin 2.

www.granthams.ie

83
NETWORK
39 Aungier Street, Dublin 2.

www.networkcafe.ie

84
PROVENDER & FAMILY - GREEN DOOR MARKET
Green Door Market, Newmarket, Dublin 8.

85
THE FUMBALLY
Fumbally Lane, Dublin 8.

www.thefumbally.ie

86
THE FAT FOX
38 Camden Row, Village Quarter, Dublin 2.

www.thefatfox.ie

87
MEET ME IN THE MORNING
50 Pleasants Street, Dublin 8.

88
BROTHER HUBBARD SOUTH
47 Harrington Street, Dublin 2.

www.brotherhubbard.ie

89
SIP & SLURP
67 Charlemont Street, Dublin 2, D02 C820.

www.sipandslurp.com

90
FIA
155b Rathgar Road, Rathgar, Dublin 6.

www.fia.ie

91
THRU THE GREEN
Dundrum Road, Windy Arbour, Dublin 14.

www.thruthegreencoffeeco.com

92
TWOBEANS SPECIALITY COFFEE BAR
11 George's Street Lower,
Dún Laoghaire, Co. Dublin.

www.twobeans.ie

MAP Nº 93
HATCH COFFEE
4 Glasthule Road, Glasthule, Co. Dublin.

www.hatchcoffee.ie

MAP Nº 94
ACT ONE CRAFT COFFEE HOUSE
4 Cutlery Road, Newbridge, Co. Kildare.

www.actonecoffee.com

MAP Nº 95
SUAS COFFEE HOUSE
31 O'Connell Street, Ennis, Co. Clare.

MAP Nº 96
CANTEEN
30 Mallow Street, Limerick, V94 EY22.

www.wearecanteen.com

MAP Nº 97
PONAIRE COFFEE
Main Street, Newport, Co. Tipperary.

www.ponaire.ie

MAP Nº 98
CORK COFFEE ROASTERS
2 French Church Street, Cork,
Co. Cork, T12 E94K.

www.corkcoffee.com

MAP Nº 99
NECTAR COFFEE
26 Parnell Place, Cork, Co. Cork.

MAP Nº 100
THE BOOKSHELF COFFEE HOUSE
78 South Mall Street, Cork, Co. Cork.

www.bookshelfcoffee.com

MAP Nº 101
ALCHEMY COFFEE AND BOOKS
123 Barrack Street, The Lough,
Cork, Co. Cork.

MAP Nº 102
ALCHEMY COFFEE
1 Langford Row, Cork, Co. Cork, T12 WK88.

MAP Nº 103
12 TABLES
Tramway House, Douglas, Cork, Co. Cork.

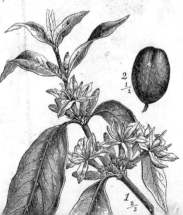

BAOBAB COFFEE ROASTERS
№18

S30

Perfect Touch

 Wide beverage menu

 Self adjusting grinders

|ıı. **Bi-directional Wi-Fi control**

LaCimbali **S30** is the new superautomatic machine created to offer up to **24 different recipes**. The grouphead design guarantees maximum reliability and consistent beverage quality, while the new milk circuit delivers hot and cold frothed milk directly to the cup.
LaCimbali **S30**, the perfect way to satisfy every taste.

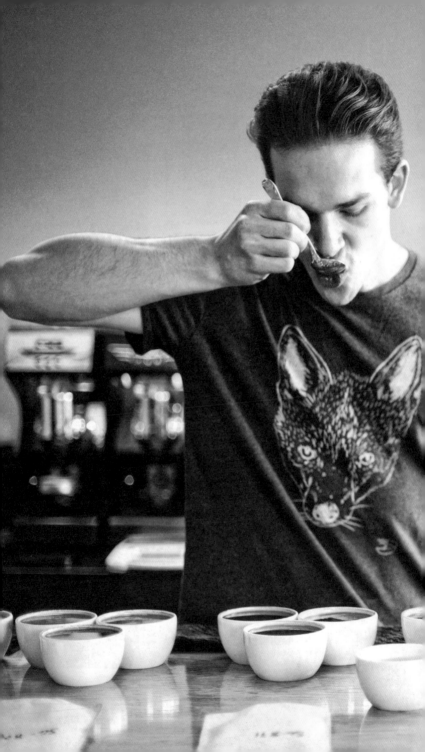

ROAST-
ERS

BAILIES COFFEE ROASTERS
№ 104

MAP № 104. BAILIES COFFEE ROASTERS

COFFEE COURSES AVAILABLE COFFEE BEANS AVAILABLE ONLINE ONSITE

27 Stockmans Way, Belfast, BT9 7ET.

www.bailiescoffee.com T: 02890 771535

f Bailies Coffee Company 🐦 @bailiescoffeeco 📷 @bailiescoffeeco

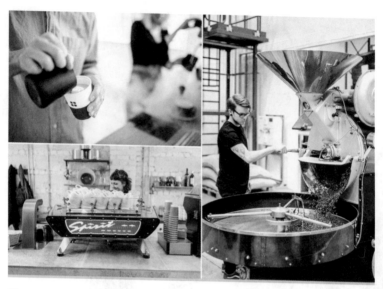

Belfast based Bailies Coffee Roasters has been roasting speciality coffee for customers across the UK, Ireland and Europe for almost 30 years.

Sourcing is something that the team takes very seriously, making regular trips to origin each year to purchase some of the finest single origins and micro lots from across the globe, as well as strengthening its commitment to the entire coffee journey – from sourcing and roasting to blending and brewing.

'BAILIES IS COMMITTED TO THE ENTIRE COFFEE JOURNEY'

'Our desire is to craft world class coffee experiences that honour the skilled labour of our farming partners across the world, with dignity and fairness. For our farming partners, we're more than a coffee roaster,' explains founder Russell Bailie. *'We work with knowledgeable farmers in locations all over the globe, bringing their coffee to Belfast and designing roast profiles which will best reveal the flavour potential.'*

Three Probat roasters in the south Belfast roastery has resulted in an impressive portfolio of coffees, and the constantly evolving collection can be found in the hopper at speciality coffee shops across Belfast and beyond. Home brewers meanwhile can select beans on the day they are roasted from the Bailies website.

To ensure exceptional coffee experiences are created, Bailies promotes only the best equipment and are distributors of the exclusive Kees van der Westen and La Marzocco machines – both industry favourites. As an official SCA training centre, the roastery also provides bespoke training and online brewing tutorials for trade customers and home enthusiasts.

MAP № 105. ARIOSA COFFEE

Borronstown, Ashbourne, Co. Meath.

www.ariosacoffee.com T: 01 8010962

f Ariosa Coffee @ariosacoffee @ariosacoffee

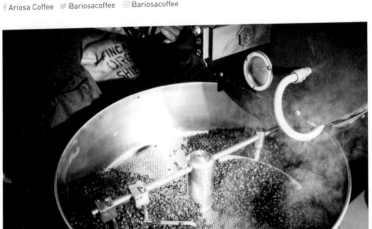

There's no praise quite like a customer declaring: *'now that's a proper cup of coffee'*. In fact, it's just the kind of compliment that the roasting aficionados at Ariosa Coffee love to hear.

'For a little while, "real coffee" was seen as single origin, lightly-roasted, fruity Ethiopian with bright acidity,' says owner Michael Kelly. *'Don't get me wrong, I love fruity coffees from Africa but not everyone likes them. And people don't want to be told that they should like something just because it's on trend.'*

As a consequence, Michael has started using the slogan: 'proper coffee'.

'It was to reassure customers that our company taste profile is suited to a broad range of people,' says the roaster who stocks 15 coffees from Central and South America, Africa and Indonesia.

It was while working at a cafe in Sydney's Woolloomooloo district that he first got bitten by the coffee bug. On his days off he would visit roaster Karmee to learn all he could about turning speciality beans into superb coffee. Clocking a gap in the home market, he returned to Ireland to set up one of its first micro roasting companies.

Fourteen years into the game and his team has just opened a smart cafe on Drogheda's Laurence Street, complete with Scandinavian furniture, a steel-and-wood coffee bar and artwork depicting Drogheda's beautiful historic buildings.

'PEOPLE DON'T WANT TO BE TOLD THAT THEY SHOULD LIKE SOMETHING'

Pastries, scones and cakes baked on the premises complete the experience. And of course, there's always a 'proper coffee' to be had, both house blend and a single origin.

'It's the staff who make my company special,' adds Michael, whose employees share his passion, knowledge and motivation for producing and serving a stonkingly good brew. *'We all have the same drive and love of coffee.'*

MAP N⁰ 106. UPSIDE COFFEE ROASTERS

Unit 14, Chart House Business Park, 157-159 Richmond Road, Fairview, Dublin, D03 R2R8.

www.upsidecoffee.com T: 085 1624966

f Upside Coffee 🐦 @upside_coffee @upside_coffee

Since setting up in the summer of 2016, Jamie O'Neill's Upside Coffee Roasters has gained such a following for its Dublin crafted coffee that the 3kg North roaster is about to be overshadowed by a 15kg big brother.

Its two main coffees are the Classic Espresso: a full-bodied chocolatey espresso that's cracking accompanied by milk, and Upside Espresso which Jamie describes as, *'a showcase of stellar, sweet Central and South American coffees which are super special. It may be fruity or have caramel notes – it just depends on what's in season. As an espresso roast, the beans are roasted with sweetness and full body in mind.'*

Both can be blends or single origin, depending on the coffee harvests, and are sourced to maintain a consistent flavour profile.

Upside's usually got around six coffees on its list at any one time, including a decaf, and the range stays lively by sourcing from right across the coffee growing world.

'We're working with an increasing number of food businesses, helping them to make coffee that sets them apart from the crowd,' says Jamie. *'We also provide ongoing barista training and assistance in finding the right equipment, so they can be confident of serving their customers truly special coffee.'*

'A SHOWCASE OF STELLAR, SWEET CENTRAL AND SOUTH AMERICAN COFFEES WHICH ARE SUPER SPECIAL'

'Upside is about making the best speciality coffee approachable and accessible to all. One of the nicest things that has happened since opening the roastery has been the number of Fairview locals who drop in for coffee and a chat.'

Nº 107. CLOUD PICKER

Unit 5, Castleforbes Business Park, Sheriff Street, Dublin 1, D01 F8C2.

www.cloudpickercoffee.ie T: 01 6978170

f Cloud Picker Coffee Roasters @cloudpickercoff @cloud_picker

Finding a name for your new micro roastery can be a tricky task, but luckily for Frank Kavanagh and Peter Sztal of Cloud Picker, a high altitude hike to reach a group of coffee pickers on a farm straddling the Thai/Burmese border provided plenty of inspiration.

After running the city's Science Gallery Cafe for three years, in 2013 the business partners turned their hand to roasting. *'The move to roasting our own coffee was a natural progression,'* explains Frank. *'There weren't many Irish indie roasters to choose from at the time and we wanted to offer something unique.'*

With backgrounds in graphic design and corporate banking, Frank and Peter sought help from a cluster of coffee consultants in the UK and France. *'It was a steep learning curve at first,'* admits Frank, *'but we've been lucky to learn from some of the best in the business, and we're continually working to perfect our roasting.'*

The months of swotting up paid off, as a couple of years down the line the roastery boasts business big-guns such as Google and Twitter, and some of Dublin's finest restaurants as Cloud Picker converts.

When you're not hopping tables at the city's swankiest eateries, you'll find Cloud Picker's two blends and selection of single origins at a cluster of speciality shops, as well as at the Science Gallery Cafe on Pearse Street.

'THE ROASTERY BOASTS GOOGLE AND TWITTER AS CLOUD PICKER CONVERTS'

Home brewers can shop a sweet selection of beans online, sourced from a range of countries along the coffee belt, which are freshly roasted on the newly upgraded Giesen W15.

108. DUBLIN BARISTA SCHOOL

19a Anne Street South, Dublin, D02 PF57.

www.dublinbaristaschool.ie T: 01 6778756

f Dublin Barista School 🐦 @dubbaristasch 📷 @dublinbaristaschool

James McCormack and his team at Dublin Barista School have the whole coffee shebang covered from every conceivable angle.

First, the team sources and roasts beans at its on-site roastery, 9th Degree Coffee Roasters. Then it serves the coffee at its Anne Street South cafe. The team also trains coffee enthusiasts to make superb coffee – before helping them bag a job as a barista through the Barista School's recruitment service, coffeejobs.ie

'IF YOU'RE LOOKING FOR A GREAT GIFT IDEA FOR A CAFFEINE HEAD, THIS IS IT'

'We also offer work experience in our shop for people who have completed their training. It's a unique way to help them get the experience required for employment,' says James.

More than 2,000 people took courses at Dublin Barista School last year and got the low-down on subjects such as: how to start a cafe; latte art; how to select green beans and the art of roasting. Courses include professional barista qualifications as well as the SCA Coffee Diploma.

'We are the only school in Ireland to offer all SCA coffee modules, and one of only three in Europe,' says James. 'We now have barista, brewing, green, roasting and sensory modules, while also offering DBS courses and online learning.'

Whether you're looking to get a job in the industry, expand your existing skills or simply love coffee and want to brew a better cup at home, chances are there's a course for you.

With a speciality coffee shop on site, this is also a great spot to sample 9th Degree Coffee Roasters' latest small batch beans.

109. TWO FIFTY SQUARE COFFEE ROASTERS

10 Williams Park, Rathmines, Dublin 6.

www.twofiftysquare.ie T: 01 4968336

f Two Fifty Square Coffee Roasters 🐦 @250squarecoffee 📷 @250squarecoffee

As with many of the game changers in the Dublin speciality scene, it was time spent in Melbourne that kick started Adam McMenamin's love of coffee. Returning to Ireland he opened a cafe and roastery under one roof and called his creation Two Fifty Square – the combined floor area of the two spaces which make up this former Rathmines bakery.

'THE TEAM IS SET TO MOVE TO A PURPOSE BUILT WAREHOUSE AND RETAIL OUTLET'

Sourcing speciality green beans from growers across the world, the team at Two Fifty strives to preserve the quality of the coffee beans during roasting and instead of over-complicating the process, allow the natural flavours to shine. The result is two stonking South American single estates and espresso blends, plus a couple of seasonally changing filters which can be sampled in a range of serve styles at the cafe.

With the business expanding rapidly, Adam now supplies coffee shops, restaurants and bars (yep, those espresso martinis are getting the speciality treatment too) across Dublin and further afield. Featured in the ever-growing list is its new sister cafe, Alpha Espresso, at the Swan Leisure Centre.

Such is the demand for Two Fifty Square's goodies that, as of July 2017, the roasting team is set to move to a purpose-built warehouse and retail outlet within close proximity of the original. The new location will be a one-stop shop for all coffee requirements, including wholesale coffee roasting and an espresso machine showroom, along with a range of apparatus for the home brewer. There are also plans afoot for a fully equipped barista training room for when you outgrow your kitchen kit.

ᴹᴬᴾ№ 110. BAOBAB COFFEE ROASTERS

COFFEE COURSES AVAILABLE | COFFEE BEANS AVAILABLE | ONLINE | ONSITE

The Mill, Celbridge, Co. Kildare.

www.baobab.ie T: 01 6274440

f Baobab Coffee Roasters 🐦 @baobabroasters 📷 @baobabroasters

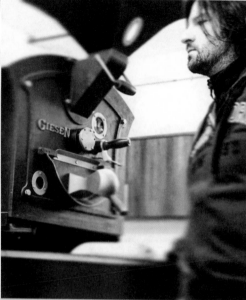

'*Coffee is a social brew,*' say Luigi Fanzini and Alex Thorpe of Baobab. It's fitting, given that the heart of the business is its founders' childhood friendship in Kenya.

'*It's where we learned about the world through many different cultural backgrounds, from Arabic speaking expats to those of European descent, all living and working together in the beautiful mosaic that is Kenya.*'

Combining their love of good coffee with the ethos of wanting to support small, passionate producers, cooperatives and wash stations, the pair have created their own roastery and nearby cafe which is the shopfront for their bean-driven enterprise.

Sourcing beans from importers as well as buying a limited stash direct, the Baobab boys stray further than their east African roots in search of the best beans, buying from harvests in Central and South America, Central Africa, Tanzania and Ethiopia too.

'THE HEART OF THE BUSINESS IS ITS FOUNDERS' CHILDHOOD FRIENDSHIP IN KENYA'

Everything is roasted on their Giesen W6A while a small Probat PRG 1Z does the business as sample roaster, where the pair try out new batches of beans and test as they go.

A recent move into the historic Mill Centre in Celbridge has provided a beautiful setting for this ethically-inspired roasting co, which is also the official distributor of Synesso espresso machines in Ireland and the UK.

Taste the coffee at the Baobab Cafe across the road and buy beans to-go there, too.

111. BELL LANE COFFEE

COFFEE COURSES AVAILABLE
COFFEE BEANS AVAILABLE
ONLINE
ONSITE

Unit 6/7, The Enterprise Centre, Clonmore, Mullingar, Co. Westmeath.

www.belllane.ie T: 044 9390777

f Bell Lane Coffee 🐦 @belllanecoffee 📷 @belllane_coffee

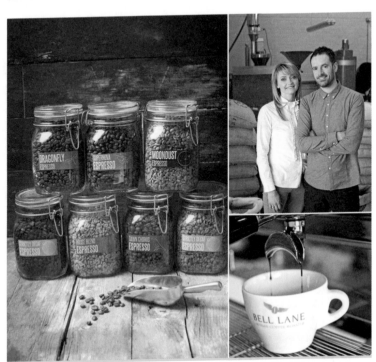

Since finding inspiration for their business name from a street spied on a visit to the London Coffee Festival in 2012, Denise and Stephen Bell have exploited their combined skills to create a roastery that's going places. Even their little white coffee bean logo has wings.

It was when the pair met roaster Paul Mooney who had 25 year's experience in the coffee industry that they knew they had found the match they were looking for.

Five years, 12 Great Taste Awards and an Irish Cafe Award for Ireland's best espresso blend later, Bell Lane supplies coffee to the country's leading cafes, coffee shops and restaurants.

Beans from right across the coffee growing belt – from Colombia to Rwanda – are roasted daily by Paul on the bespoke 15kg Giesen.

'STEPHEN IS ONE OF A HANDFUL OF Q GRADERS IN IRELAND AND IS BELIEVED TO BE THE ONLY ROASTERY OWNER TO HOLD THIS QUALIFICATION'

Roasting in small batches is the key to Bell Lane's consistently high quality coffee and allows Paul to create a cracking range of bespoke blends.

MAP 112. ANAM MICRO COFFEE ROASTERY

COFFEE COURSES AVAILABLE COFFEE BEANS AVAILABLE ONLINE ONSITE

Kilcorney, Kilfenora, Co. Clare, V96 YV40.

www.anamcoffee.ie T: 085 1316665

f Anam Coffee 🐦 @burrencoffee 📷 @burrencoffee

Named after the Irish word for soul or spirit, this tiny and relatively new micro roastery lives up to its name "Anam" in more ways than one.

Brian O'Briain, Anam Coffee's founder and roast master is proud of his west coast roots.

'Our remote location in the UNESCO Geopark of The Burren, provides a stunning backdrop to everything we do.

'We are part of a small farming community which celebrates each harvest and farms sustainably. And in the same way, we source speciality coffee seasonally and ensure farmers are well rewarded for farming responsibly.'

The name Anam represents a sense of place, and a way of life which has endured against the odds.

'The pace of life is slower here. We take time to find extraordinary beans full of personality and ensure each coffee has its own individual roast profile.

'We produce coffee that has taken time to grow, time to get here, time to profile and which deserves to be savoured,' says Brian.

'Not only are we passionate coffee roasters, we're also storytellers, sharing and celebrating the story of coffee.

'We explain where our coffees come from, how they are grown and, importantly, by whom.'

1kg and 15kg Giesens do the honours to produce smooth, sweet and full bodied blends which are showcased in local cafes, restaurants and hotels. In addition, a small number of single origin coffees are roasted for sale online and through speciality coffee shops island-wide.

'OUR REMOTE LOCATION PROVIDES A STUNNING BACKDROP'

Anam Coffee is part of The Burren Food Trail and from summer 2017, visitors are invited to private tastings, cuppings and exclusive roastery tours. Visit www.anamcoffee.ie/events for dates and further information.

№113. BADGER & DODO BOUTIQUE COFFEE ROASTERS

COFFEE BEANS AVAILABLE ONLINE

Fermoy, Co. Cork.

www.badgeranddodo.ie T 085 7062019

f Badger & Dodo Boutique Coffee Roasters @badgeranddodo

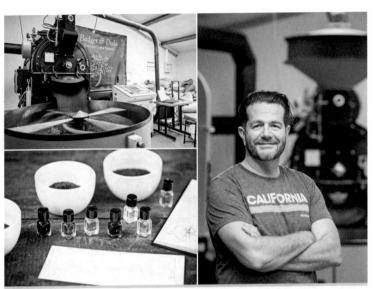

Pulling his first shot with pioneers riding the Sydney wave in 1993, and cementing his interest via the Melbourne speciality scene in the Noughties, it was only natural that Aussie Brock Lewin would turn his trade to coffee when he emigrated to County Cork in 2008.

Inspired to introduce speciality coffee to Ireland outside of Dublin, the decision to set up his roastery on his in-laws' farm in Fermoy not only gave him the space to experiment but also an intriguing name for his new brand.

'Brock is Irish for badger, and dodo was my father-in-law's childhood nickname,' explains Brock, 'and I wouldn't be where I am without him.'

The original roastery was rebuilt in 2013 to house the arrival of Doctor O, a customised cast iron 30kg roaster, introduced to ramp up the output from the existing 1kg and 10kg machines.

Every beany baby delivered by the doctor is rigorously checked for quality and consistency. And continuous cupping to refine the roast is carried out by Elia Burbello, Badger & Dodo's own Q grader.

'THE ORIGINAL ROASTERY WAS REBUILT IN 2013 TO HOUSE THE ARRIVAL OF DOCTOR O'

The result of this lengthy process is a top-notch selection of blends, single origins, single estates and micro lot coffees, which the guys supply to nearly 200 venues across the country, including their own speciality cafe in Galway.

Home brewers can browse the line-up online, with Badger & Dodo faves also available to buy as green beans for any aspiring roasters. Training for both customers and future baristas is available at the roastery with SCA qualified trainer, Elia.

114. THE GOLDEN BEAN

Ballymaloe House, Shanagarry, Midleton, Co. Cork.

www.thegoldenbean.ie T: 086 8366325

f The Golden Bean 🐦 @thegoldenbean 📷 @thegoldenbean.ie

This Must Be The Cafe... by the Golden Bea

This coffee roastery in Shanagarry was started by Marc Kingston in a tiny cottage on the grounds of Ballymaloe House (the famous five star hotel and restaurant) seven years ago, with the aim of sourcing, roasting and supplying the most ethically produced beans from around the globe.

'I COULD SEE THERE WAS AN OPPORTUNITY TO ROAST EXACTLY THE KIND OF COFFEE I WANTED TO SELL'

Such a foodie setting is eminently suitable for this artisan outfit which only deals in single estate beans for its 11-14 coffees.

As the business has grown, Marc has had to split the roasting between two rooms, with his old Probat L5 still occupying the cottage and a new chunky Giesen 15kg taking over a larger location in the Ballymaloe grounds.

Roasting is a relatively recent chapter in the business' story, which began as a coffee specialist selling beans from a variety of roasters to caffeine fans at events and markets. Customers can still visit The Golden Bean stalls at Mahon and Douglas farmers' markets, although nowadays the team only sells its own beany haul.

'We started the event and market coffee business in 2007 to see if developing our own roastery in Cork was viable,' says Marc. 'At that time we concluded that it wasn't, but within a few years I could see there was an opportunity to roast exactly the kind of coffee I wanted to sell.'

Now The Golden Bean roasts are sold to over 30 independent businesses in the Cork area, offering an authentic taste of the region.

№115. CORK COFFEE ROASTERS

COFFEE COURSES AVAILABLE · COFFEE BEANS AVAILABLE · ONLINE · ONSITE

2 Bridge Street, Cork, Co. Cork, T23 PY7H.

www.corkcoffee.com T: 021 7319158

f Cork Coffee Roasters 🐦 @corkcoffee 📷 @corkcoffeeroasters

When it comes to bean alchemy, John and Anna Gowan know a thing or two. Caffeine addicts across Ireland seek out their magical beans, which have been metamorphosed into the source of a rich elixir via a pair of vintage, traditional roasters.

John, who spent 15 years as a fisherman off the Alaskan coast, learned these skills from his friends, who just happened to be a group of successful, independent roasters living in the coffee-mad city of Seattle. Anna, meanwhile, has a background in the food and restaurant sector.

'At the time of our move to Ireland there was little-to-no coffee culture here and we saw an opportunity to do our own thing,' she says.

Attention to detail is extremely important at this labour-intensive, highly-skilled, small-scale production hub which supplies both its own two cafes and a variety of customers.

'We oversee every aspect of the business, so we are personally invested in our customers' experience with us,' Anna explains.

The signature blend is Rebel City Espresso, perfect for fans of a bold, rich and complex coffee. Morning Growler, meanwhile, is ideal for the french press and delivers a refreshing hit first thing.

Hospitality businesses across Ireland also rely on these talented Corkonians to help them get the best out of every bean with further training and advice.

'WE ARE PERSONALLY INVESTED IN OUR CUSTOMERS' EXPERIENCE'

'One of the aspects we enjoy most is the opportunity to work closely with customers to help them realise their vision for a high quality coffee business – from choosing the right machine to helping with cafe layout,' says Anna.

116. BARISTA SCHOOL IRELAND

15 Maylor Street, Cork, Co. Cork, T12 XC78.

www.baristaschoolireland.ie T: 021 424717

f Barista School Ireland - BSI 🐦 @bsi_irl 📷 @baristaschoolireland

I t's no secret why so many wannabe baristas choose to train with Barista School Ireland (BSI). Because from latte art to grinder trouble-shooting, the topics covered are extremely practical.

'We're probably the largest dedicated barista training facility in Ireland, with competition-spec equipment and leading teachers, as well as on-going support long after the course ends,' says operations director Sean Kennedy.

'A GOOD BARISTA DOES A JOB; A GREAT BARISTA MAKES A DIFFERENCE'

He's a man who knows the sharp end of coffee service, as four years ago he opened Warren Allen Coffee in Bandon, which he followed with another outlet in Cork City centre.

'We recruited and trained all our staff from virtually zero coffee knowledge to become top class baristas and team players,' says Sean. *'We felt it was time to share our knowledge with the public and contribute to furthering speciality coffee in Ireland.'*

Hence the birth of BSI with colleague Vincenzo Bellone, who heads up a portfolio of training courses aimed at everyone from the home enthusiast and industry novice to skilled baristas and supervisors.

According to Sean there is often a slim margin between a good barista and a great one.

'A good barista does a job; a great barista makes a difference,' he says. *'Our students usually find brilliant jobs through BSI's network of partner businesses throughout the country.'*

The school has also led the development of coffee jobs website, JOBO.ie which links BSI's talented graduates with burgeoning coffee businesses.

In its consultancy wing, BSI staff call upon years of experience in the industry to offer coffee shops a client-centred approach.

'We've made mistakes and we've learned what works,' adds Sean. *'It's through this experience that we help businesses realise their coffee potential.'*

117. WEST CORK COFFEE

The Forge, Innishannon, Co. Cork.

www.westcorkcoffee.ie T: 086 3183236

f West Cork Coffee 🐦 @westcorkcoffee 📷 @westcorkcoffee

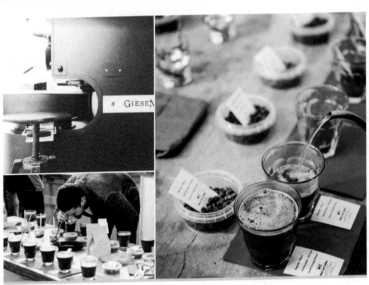

Tony Speight built his first roaster in 2005, and his meticulous labour of love was a significant milestone on this electrical engineer's journey from enthusiastic bean hobbyist to passionate artisan roaster.

Continually honing his roasting skills, Tony soon started to garner a following of loyal fans seeking out his superb small batch coffees.

'I ALWAYS WANT TO PUSH MY ROASTING ABILITIES AND SEEK OUT INSPIRATIONAL CHALLENGES'

To stay abreast of demand he splashed out on a larger Giesen roaster, custom built in The Netherlands. And this bean-enhancing beauty, coupled with a move to a new venue at The Old Forge at Innishannon, equipped him with the capacity to roast up to 6kg of beans at any time.

Selecting quality beans from small producers in Ethiopia, Brazil, Colombia, Mexico and Rwanda, Tony now roasts according to the needs of his customers, supplying unique coffees to restaurants and speciality coffee shops in Cork City and West Cork.

'I'm energised and always want to push my roasting abilities and seek out inspirational challenges,' he says.

One such challenge was to provide top barista Vincenzo Bellone with a killer coffee to compete in the London Coffee Masters.

'We decided on a washed red catuai from Honduras,' says Tony. *'It produces amazing notes of maple syrup, liquorice and almond.'*

Cupping events, roasting workshops and roastery visits (by appointment only) are high on the West Cork Coffee agenda, as is coffee education.

'We provide customised roasts, barista training and an overall understanding of what speciality coffee entails. It's a completely immersive service,' he adds.

MORE GOOD ROASTERS

Additional hot hauls for your hopper

MAP № 118
ROOT & BRANCH COFFEE ROASTERS
1b Jameson Street, Belfast, BT7 2GU.
www.rootandbranch.coffee

MAP № 119
CAFE LOUNGE
Unit 3, Mercantile Plaza,
Carrick-On-Shannon, Co. Leitrim.
www.cafelounge.ie

MAP № 120
JAVA REPUBLIC
510 Mitchelstown Road, Northwest
Business Park, Ballycoolin, Dublin 15,
D15 PY8H.
www.javarepublic.com

MAP № 121
IMBIBE COFFEE
Unit 83, Baldoyle Industrial Estate,
Baldoyle, Dublin.
www.imbibe.ie

MAP № 122
SILVERSKIN COFFEE ROASTERS
Unit 13, Blackwater Road, Dublin
Industrial Estate, Dublin 11.
www.silverskincoffee.ie

MAP № 123
FULL CIRCLE ROASTERS
21-28 Talbot Place, Dublin 1.
www.fullcircleroasters.ie

MAP № 124
9TH DEGREE COFFEE ROASTERS
28 Westmorland Street, Dublin 2.
www.9thdegree.ie

MAP № 125
3FE
32 Grand Canal Street Lower, Dublin 2.
www.3fe.com

№126
KHANYA CRAFT COFFEE
Suite 19, The Mall, Beacon Court,
Sandyford, Dublin 18.

www.khanyacraftcoffee.com

№127
ROASTED BROWN
The Delgany, Delgany, Co. Wicklow.
www.roastedbrown.com

№128
MCCABE'S COFFEE
Unit 1, Newtown Business Park,
Newtownmountkennedy, Co. Wicklow.

www.mccabecoffee.com

№129
COFFEE MOJO
Unit W6, Wicklow Enterprise Centre,
The Murrough, Wicklow Town,
Co. Wicklow.

www.coffeemojo.ie

№130
CRAIC COFFEE ROASTERS
The Heath, Co. Laois.

www.craiccoffeeroasters.ie

№131
PONAIRE COFFEE
Main Street, Newport, Co. Tipperary.

www.ponaire.ie

COFFEE GLOSSARY

ESPRESSO

BARISTA
The multi-skilled pro making your delicious coffee drinks.

CHANNELING
When a small hole or crack in the coffee bed of espresso forms, resulting in the water bypassing the majority of the ground coffee.

DISTRIBUTION
The action of distributing coffee evenly inside the espresso basket before tamping to encourage even extraction. This can be achieved through tapping, shaking or smoothing the coffee out with your fingers.

DOSE
The amount of ground coffee used when preparing a coffee.

GOD-SHOT
The name given to a shot of espresso when all the variables are in line and the coffee tastes at its optimum.

GRAVIMETRIC
The term for an espresso machine with the technology to control the yield, based on coffee dose.

OCD
Tool used for distributing coffee inside the espresso.

PRESSURE PROFILING
The act of controlling the amount of pressure applied to espresso throughout the extraction time, resulting in different espresso flavours and styles.

ROSETTA
The name given to the fern-like latte art pattern served on the top of a flat white or other milk drink.

TAMP
The action of compacting coffee into the espresso basket with a tamper in order to encourage even extraction.

YIELD
The volume of liquid produced when preparing an espresso or brewed coffee. A traditional espresso would yield twice that of the coffee dose. For example if you use 18g of coffee to brew an espresso, then you might yield 36g of liquid.

FILTER

AGITATE

Stirring the coffee throughout the brew cycle when preparing filter coffee to increase strength or encourage even extraction.

BATCH BREW

Filter coffee prepared on a large scale using a filter coffee machine.

BLOOM

The action of pouring water on freshly ground coffee to evenly coat each coffee particle. This encourages even extraction.

BREW

The general term given to filter coffee – as opposed to espresso.

CASCARA

The outer skin of the coffee cherry can be used to make an infusion served hot like a tea or cold, mixed with sparkling water.

COFFEE BLOSSOM

The flowers collected from the coffee bush are dried and can be used to make a tea-like infusion.

COLD BREW

Coffee brewed using cold water and left to extract over a longer period. Served cold, this coffee has high sweetness and low acidity.

CUPPING

The international method used to assess coffee. The beans are ground to a coarse consistency and steeped in a bowl of hot water for four minutes before the crust of grounds is scraped away from the surface. The coffee is left to cool and assessed via a big slurp from a cupping spoon.

EK 43

Popular grinder used for both espresso and filter.

'A COFFEE WITH 90 OR MORE POINTS WILL USUALLY BE QUITE EXCLUSIVE, TASTY AND EXPENSIVE!'

BEANS

ARABICA

The species of coffee commonly associated with speciality coffee, arabica is delicate and grows at high altitudes. It has lower levels of caffeine and typically higher perceived acidity, sweetness and a cleaner body.

BLEND

A blend of coffee from different farms and origins, traditionally used for espresso.

HONEY PROCESS

This process sits in-between washed and natural. The seeds are removed from the cherry and then left to dry with the mucilage intact, resulting in a sweet coffee with some characteristics of washed and natural process coffee.

NATURAL PROCESS

Naturally processed coffee is picked from the coffee bush and left to rest for a period of time with the fruit of the coffee cherry intact. In some cases the cherry can be left like this for two weeks before being hulled off. This results in a fruity, full body.

NINETY PLUS

All coffee is graded before sale with points out of 100. Speciality coffee will have 80 or more points. A coffee with 90 or more points is referred to as 90+ and will usually be quite exclusive, very tasty and expensive!

ROBUSTA

A low grade species of coffee, robusta grows at lower altitudes. This species has a high caffeine content and displays more bitterness and earthy flavours.

SINGLE ORIGIN

The term usually used for coffee from one origin. Single estate is the term used for coffee from one farm. Can be used for espresso or filter.

WASHED

Washed coffee is picked from the coffee bush and the outer layers of the cherry are immediately removed from the seed (what you normally call the coffee bean) and put into fermentation tanks to remove the layer of sticky mucilage before being laid out to dry. This washing process removes some of the sugars and bitterness so the coffee should have a higher acidity and lighter body.

Hannah Davies

MEET OUR COMMITTEE

Our *Independent Coffee Guide* committee is made up of a small band of coffee experts from across Ireland who have worked with Salt Media and the Irish coffee community to oversee the creation of this book

JAMES SHEPHERD

International sales manager for cafe bar supplies company Beyond the Bean, James has worked in the coffee industry for 14 years. Starting his career with a leading UK roaster in 2002, he relocated to Dublin in 2006. James has competed in the Scottish Barista Championships and UK finals twice. He's also judged for the UKBC, IBC and WBC as well as MCing at the latter. He serves on the advisory board for World Coffee Events and is a past member of the SCA board.

GER O'DONOHOE

Ger is a passionate educator and career barista from Dublin. His company, First Draft Coffee, opened its doors four years ago and has earned an enviable reputation as a seat of coffee excellence in Ireland. Ger has recently been elected as Irish education coordinator for the SCA, opened his first cafe space and is celebrating 20 years behind the counter.

BRIDGEEN BARBOUR

Working in coffee for over 10 years, Bridgeen opened Established in 2013 with partner Mark. The popular Belfast coffee shop has a clear emphasis on quality espresso and filter alongside excellent seasonal food. *'I love how cafe life brings so many different people together and it's fantastic to have the opportunity to serve some of the best coffee in the world to our customers,'* she says. Away from coffee, Bridgeen has a PHD in psychology.

KARL PURDY

Before launching his string of speciality shops and mobile brew bars, Karl was an aspiring photo journalist. Returning to Belfast in 1995, he launched one of the city's first coffee shops to great acclaim. Relocating to Dublin and starting again from scratch, Karl opened a little coffee cart on Howth's East Pier. On its first day Coffeeangel served 150 coffees. Thirteen years later it has six outposts across the city and has served over one million cups of speciality coffee.

COFFEE NOTES

Somewhere to save details of specific brews and beans you've enjoyed

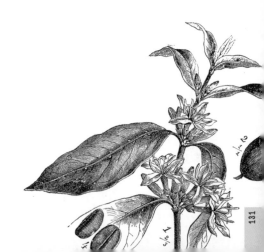

COFFEE NOTES

Somewhere to save details of specific brews and beans you've enjoyed

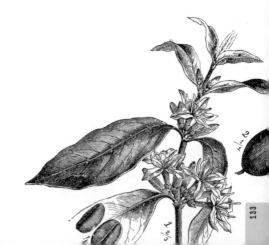

COFFEE NOTES

Somewhere to save details of specific brews and beans you've enjoyed

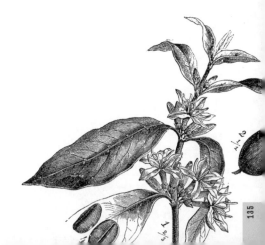

INDEX